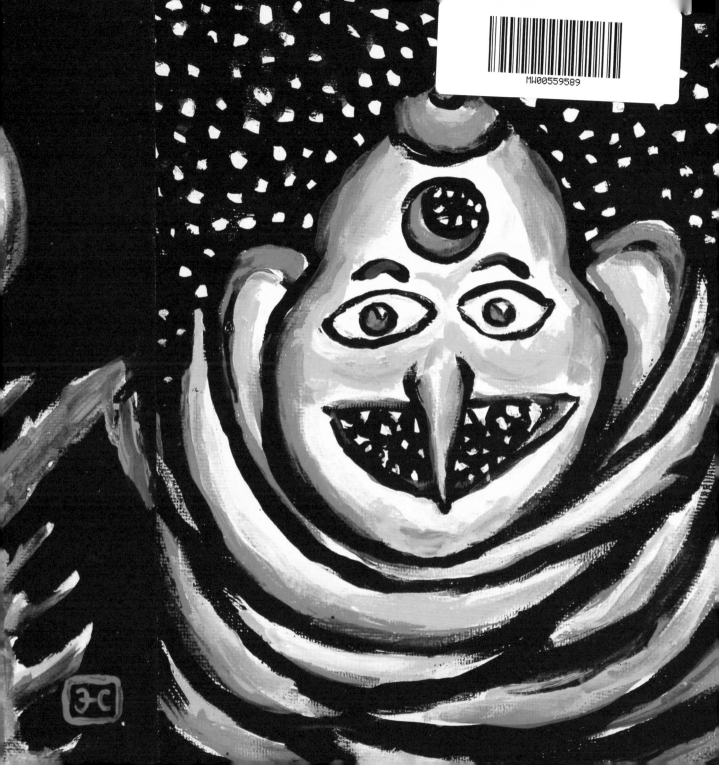

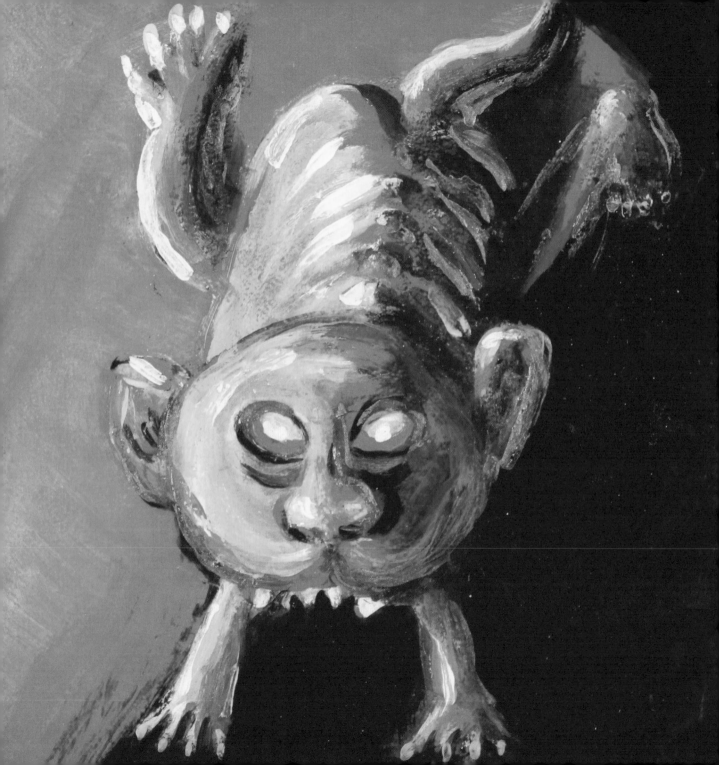

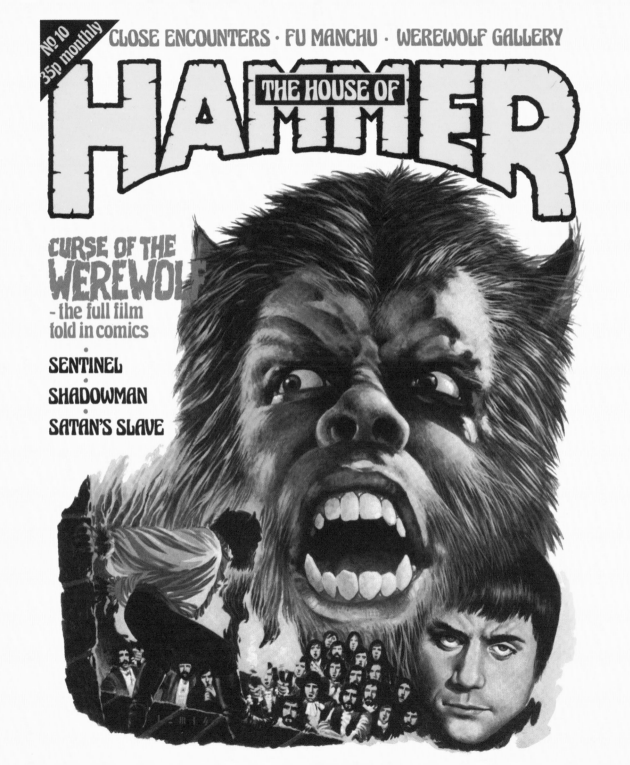

Nº 10
35p monthly

CLOSE ENCOUNTERS · FU MANCHU · WEREWOLF GALLERY

THE HOUSE OF

HAMMER

CURSE OF THE
WEREWOLF
– the full film
told in comics

·

SENTINEL

SHADOWMAN

SATAN'S SLAVE

1

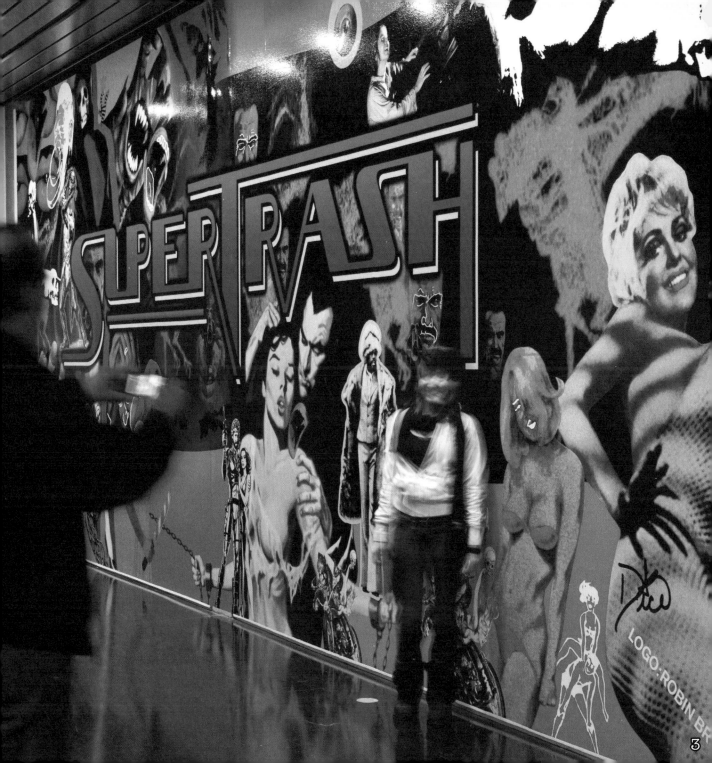

5

ORIGINAL MOTION PICTURE SOUNDTRACK

JAMES CAAN

Thief

COMPOSED AND PERFORMED BY

TANGERINE DREAM

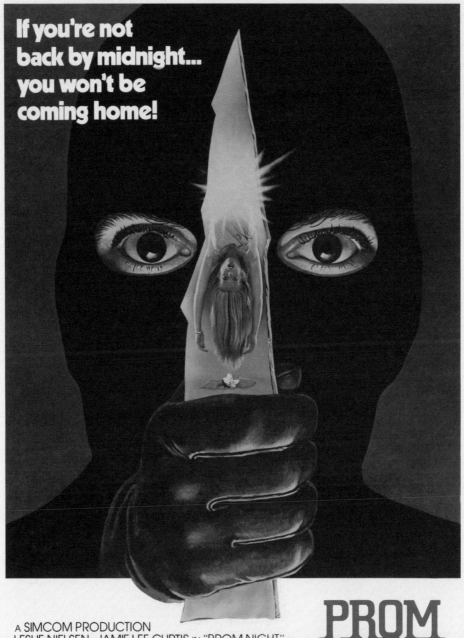

If you're not
back by midnight...
you won't be
coming home!

A SIMCOM PRODUCTION
LESLIE NIELSEN · JAMIE LEE CURTIS IN "PROM NIGHT"
SCREENPLAY BY WILLIAM GRAY · STORY BY ROBERT GUZA, JR.
PRODUCED BY PETER SIMPSON · DIRECTED BY PAUL LYNCH
AVCO EMBASSY PICTURES Release
© 1980 AVCO EMBASSY PICTURES CORP.

PROM
NIGHT

800110

10

11

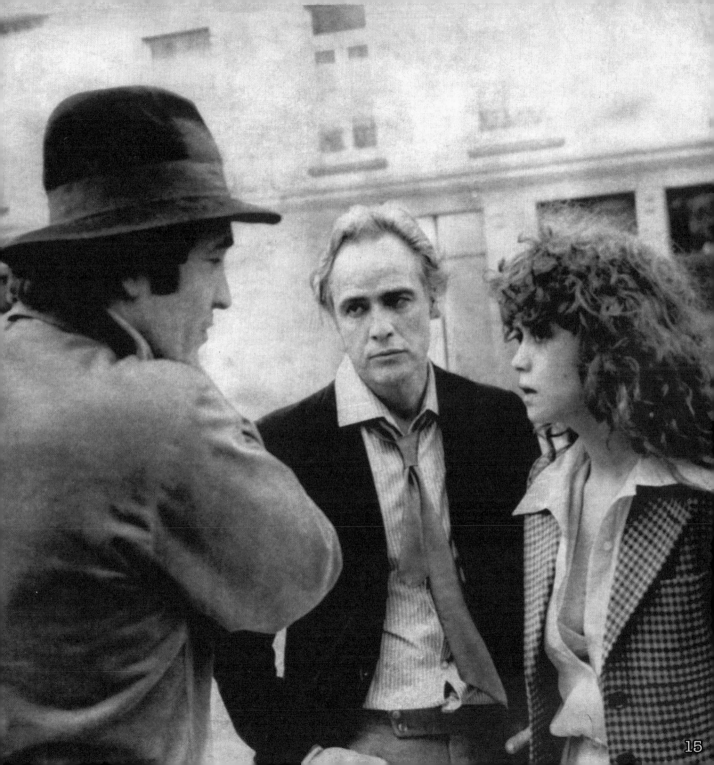

15

Dedicated to
Kierkegaard and
Thin Lizzy

Curator/Author:
Jacques Boyreau

Editorial Liaison:
Gary Groth

Copy Editor:
Michael Catron

Designers:
Mike Skrzynski
Joe Niem
Christina Iron
Olga Lopata

Associate Publisher:
Eric Reynolds

Publisher:
Gary Groth

Cover: Joe Niem
(Stylist: Jenny Kim)

Art by Tim Colley (pgs. 25, 42, 81, 204, 205, 215)
Art by Joe Niem (pgs. 4, 5, 82, 181)
Art by Jim Blanchard (pgs. 39, 127, 135, 154)

Art by Cornelia Jensen (pgs. 98, 163, 164, 165, 188)

Art by Mats (pg. 99)

Photos by Chris Arend (pgs. 2, 3, 104, 105, 106, 107)

Photos by Richard Stoner (pgs. 100, 101, 102, 103)

Photos by Allan deLay printed by Tom Robinson (pgs. 88, 93)

"Weird Tales of The Werepad" and SuperTrash cover logo by Joe Niem and Matt DeLight

End paper paintings by Fred Colley

"Rockydrome" by Tim Colley

Special thanks to: Ninkasi, Greg Pierce, Tim Rotramel, Roger Paulson, Scott Moffett, Andy Warhol Museum, Anchorage Museum, and "Refacimento" artists: *Dash Shaw, Eric Skillman, Tom Neely, Jon Sperry, Pieter Van Eenoge, Mark Reusch, David King, Nathan Hail, Brent Wear, Baron Raoul, Angie Wang, Alex Itin*

Additional thanks to: Randall Bethune, Big Planet Comics, Black Hook Press of Japan, Nick Capetillo, Kevin Czapiewski, John DiBello, Juan Manuel Domínguez, Mathieu Doublet, Dan Evans III, Thomas Eykemans, Scott Fritsch-Hammes, Coco and Eddie Gorodetsky, Karen Green, Ted Haycraft, Eduardo Takeo "Lizarkeo" Igarashi, Nevdon Jamgochian, Andy Koopmans, Philip Nel, Vanessa Palacios, Kurt Sayenga, Anne Lise Rostgaard Schmidt, Christian Schremser, Secret Headquarters, Paul van Dijken, Mungo van Krimpen-Hall, Jason Aaron Wong, and Thomas Zimmermann

Fantagraphic Books, Inc.
7563 Lake City Way NE
Seattle WA 98115

To receive a free catalogue of more books like this, as well as an amazing variety of cutting-edge graphic novels, classy comic books, and newspaper strip collections, eclectic prose novels, visually stunning art books, and uniquely insightful cultural criticism, call (800) 657-1100 or visit Fantagraphics.com. Follow us on Twitter at @fantagraphics and on Facebook at facebook.com/fantagraphics.

First Fantagraphics Books edition: October 2014
ISBN 978-1-60699-738-3
Printed in Hong Kong

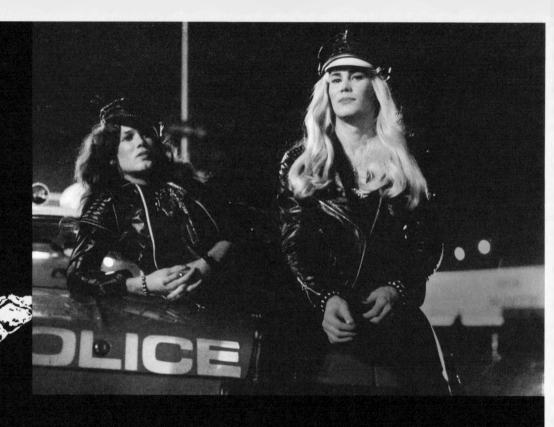

AL PACINO
CRUISING

 Released thru
United Artists
©1980 LORIMAR DISTRIBUTION INTERNATIONAL.
ALL RIGHTS RESERVED.

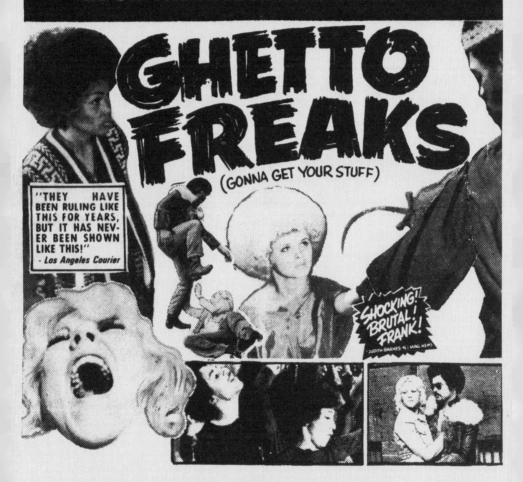

FANGORIA

The #1 Horror Magazine
—Now in our 10th year!

$3.50 U.S./$4.50 CANADA
JULY
K47909
DGS
U.K.
£2.50

GHOSTBUSTERS II
Who ya gonna call?

STEPFATHER II
He ain't Cosby

Jason's babes—
Sexy screamers

FRIDAY THE
13TH TV
Behind the scenes

Remaking PIT &
THE PENDULUM
Blood! Witches! Poe!

Newest horror videos

EC horror returns!

THE BORROWER
wants your head!

Santa
slays
again!

TALES
FROM
THE
CRYPT

22

FROM BEYOND's brain-eater

see pag 27

FANGORIA

HORROR IN ENTERTAINMENT

$2.95 U.S./$3.75 CANA

RAWHEAD REX

THE KINDRED
Designer genes gone bad!

Horror Heroes:

Dick Smith—
Makeup lessons
from the Master

John Getz—
Bugged by THE FLY

Dick Miller—
Latest from fear's
favorite actor

Jeff Hogue—
Video terror king

Monster Moguls:
Hammer & AIP scream
histories!

Clive
Barker's
bloodbeast
chews
'em up!

23

SNAGGLETOOTH ACTION FIGURE Another one of the Cantina aliens who gave Luke and Obi Wan-Kenobi a hard time as they tried to escape Tatooine and the Imperial Troopers. Comes with laser rifle, articulated arms and legs. This grey skinned alien wears a bright red pressure suit that has a black belt and black trim. Snaggletooth stands a deadly 2¾" high! #24218/$2.95

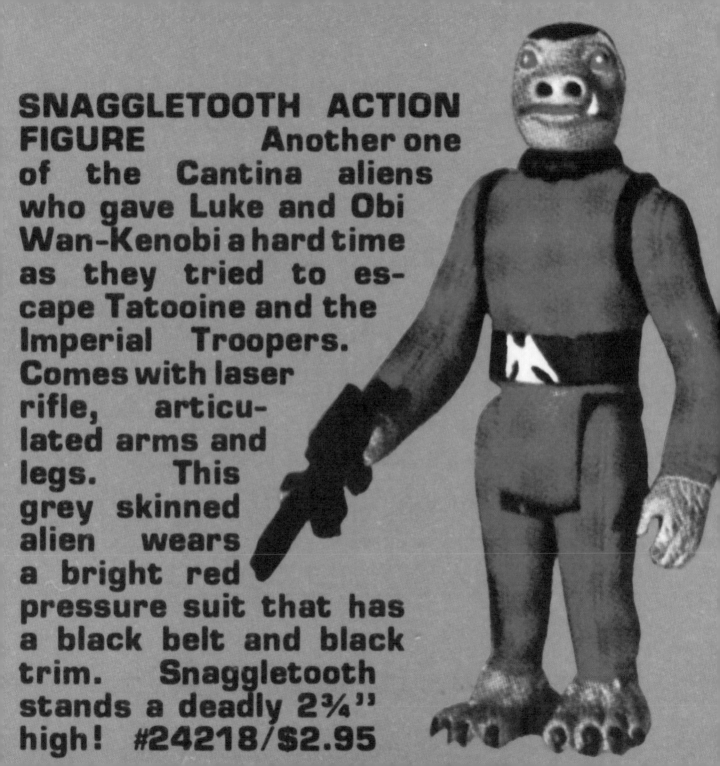

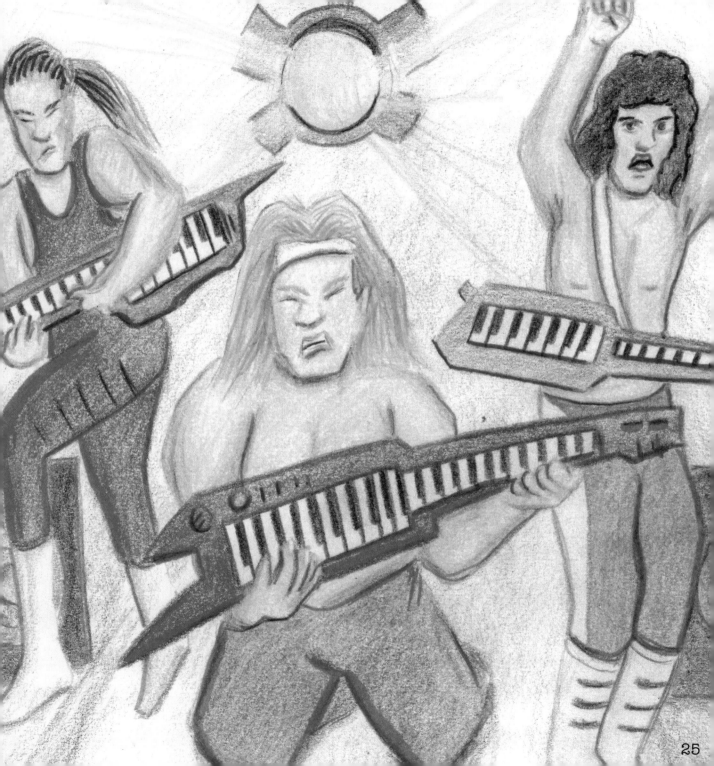

25

NICK NOLTE
is Jack Benteen
EXTREME PREJUDICE

Six soldiers. Officially heroes. Officially dead.
Using advanced weaponry to operate outside the law.
Now they're up against a stone age cowboy with just a rifle and a tin badge.

The odds are even.

MARIO KASSAR and ANDREW VAJNA present
A WALTER HILL film NICK NOLTE
"EXTREME PREJUDICE" POWERS BOOTHE MARIA CONCHITA ALONSO music by JERRY GOLDSMITH director of photography MATTHEW F. LEONETTI, a.s.c.
executive producers MARIO KASSAR and ANDREW VAJNA story by JOHN MILIUS and FRED REXER screenplay by DERIC WASHBURN and HARRY KLEINER
produced by BUZZ FEITSHANS directed by WALTER HILL A TRI-STAR RELEASE

ON THE STREET
THE REAL TRICK IS
STAYING ALIVE.

VICE
SQUAD
...The Real Story.

AVCO EMBASSY PICTURES PRESENTS

SEASON HUBLEY IN "VICE SQUAD" A SANDY HOWARD PRODUCTION IN ASSOCIATION WITH HEMDALE LEISURE CORPORATION
STARRING GARY SWANSON WINGS HAUSER WRITTEN BY SANDY HOWARD AND KENNETH PETERS AND ROBERT VINCENT O'NEIL
PRODUCED BY BRIAN FRANKISH DIRECTOR OF PHOTOGRAPHY JOHN ALCOTT EXECUTIVE PRODUCERS SANDY HOWARD ROBERT REHME FRANK CAPRA JR.
DIRECTED BY GARY A. SHERMAN AVCO EMBASSY PICTURES Release

RESTRICTED

NSS 820012

27

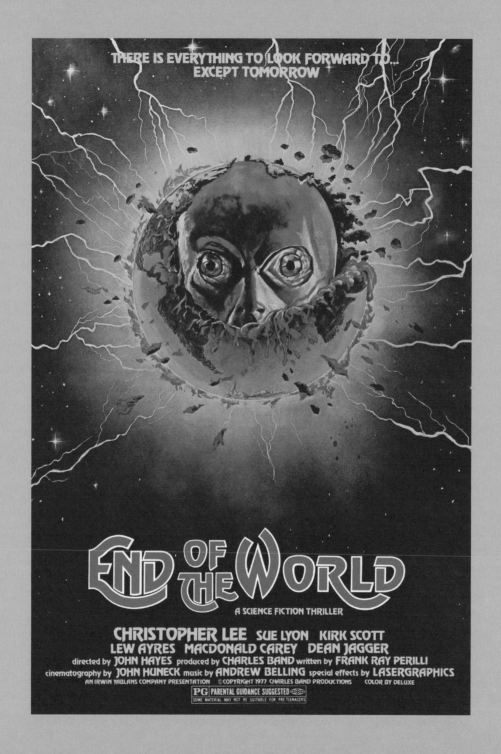

28

We wish this movie
was about
sex,
drugs,
and rock n' roll...
but two out of three ain't bad!

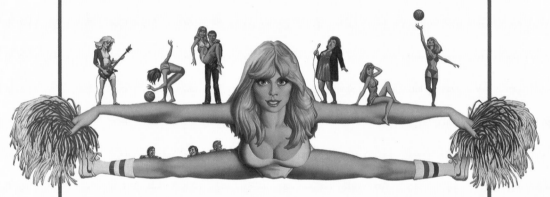

The comedy with sizzle.

FEATURING MUSIC BY:

Blondie	Del Shannon
Bonnie Tyler	John Hiatt
Rick Derringer	American Patrol
The Olympics	

EDWARD L. MONTORO presents "SPLITZ" Starring ROBIN JOHNSON RAYMOND SERRA PATTI LEE CHUCK McQUARY
BARBARA M. BINGHAM and SHIRLEY STOLER as DEAN HUNTA Co-starring MARTIN ROSENBLATT Music By GEORGE SMALL
Edited By RICK SHAINE Director Of Photography RONNIE TAYLOR B.S.C. Executive Producer STEPHEN LOW
Produced By KELLY VAN HORN & STEPHEN LOW and FRANK LaLOGGIA
Directed By DOMONIC PARIS FROM FILM VENTURES INTERNATIONAL

29

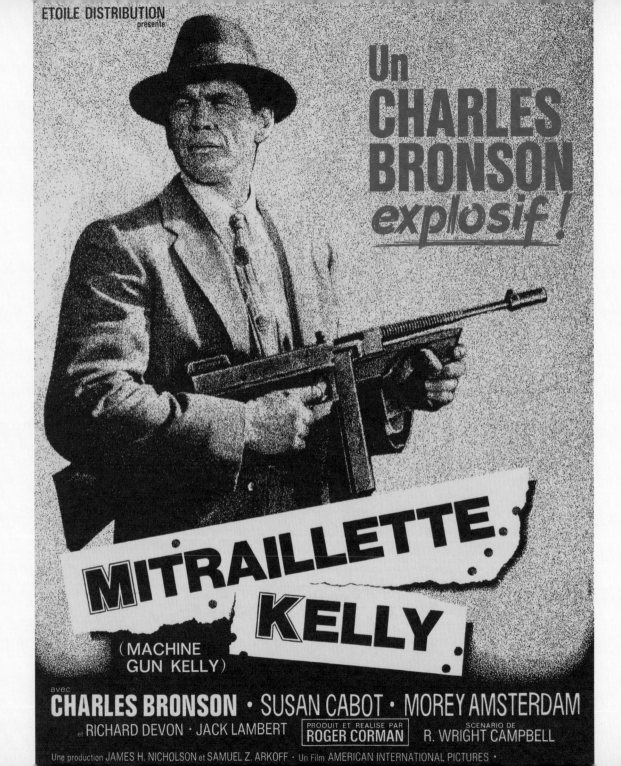

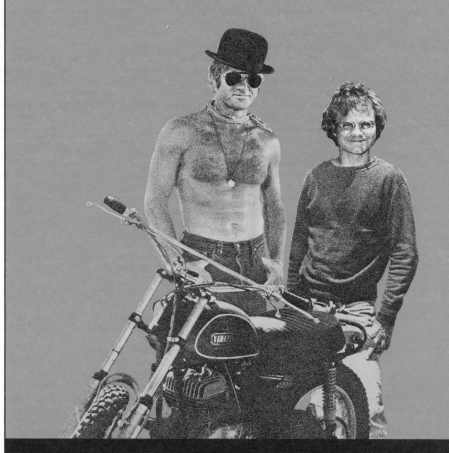

Little Fauss and Big Halsy are not your father's heroes.

PARAMOUNT PICTURES PRESENTS

ROBERT REDFORD MICHAEL J. POLLARD

LITTLE FAUSS AND BIG HALSY

AN ALBERT S. RUDDY PRODUCTION

Co-starring **LAUREN HUTTON** **NOAH BEERY** **LUCILLE BENSON**

Produced by **ALBERT S. RUDDY** Written by **CHARLES EASTMAN** Directed by **SIDNEY J. FURIE** Songs sung by **JOHNNY CASH**

Filmed in PANAVISION Color by MOVIELAB A PARAMOUNT PICTURE

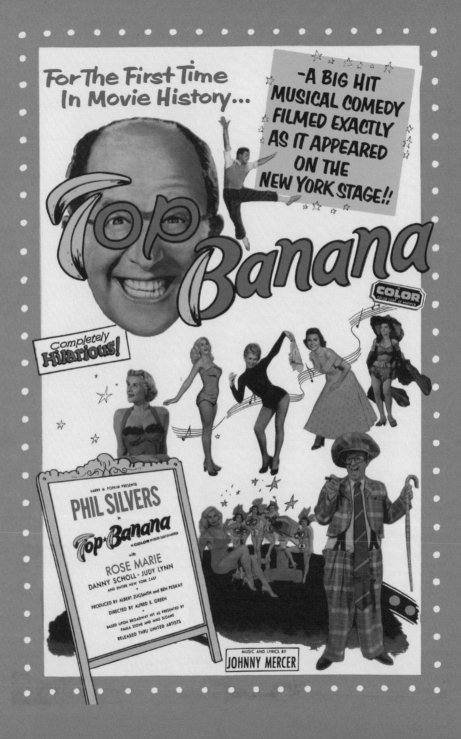

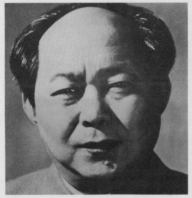

"This is it.
They're finally together.
Right now we can
detonate our explosive
and destroy the Chairman."

Mao Tse-Tung is The Chairman. Gregory Peck is the explosive.

20th Century-Fox presents

GREGORY PECK · ANNE HEYWOOD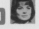

An Arthur P. Jacobs Production

"THE CHAIRMAN"

Co-starring
ARTHUR HILL · ALAN DOBIE · FRANCISCA TU · ORI LEVY · ZIENIA MERTON · And Introducing **CONRAD YAMA** as The Chairman

Produced by **MORT ABRAHAMS** · Directed by **J. LEE THOMPSON** · Screenplay by **BEN MADDOW** · Based on the Novel by **JAY RICHARD KENNEDY**

Music by **JERRY GOLDSMITH** · Made by Twentieth Century-Fox Productions Ltd. · **Panavision**® **Color** by DeLuxe

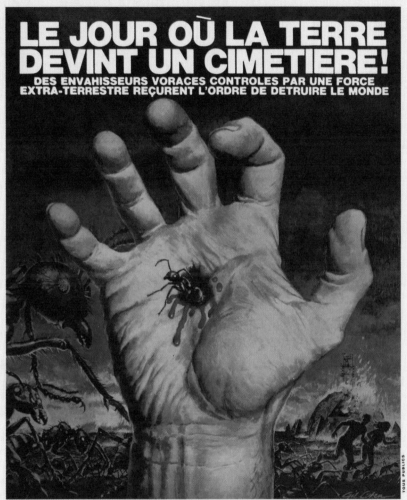

LE JOUR OÙ LA TERRE DEVINT UN CIMETIERE!
DES ENVAHISSEURS VORACES CONTROLES PAR UNE FORCE
EXTRA-TERRESTRE REÇURENT L'ORDRE DE DETRUIRE LE MONDE

PHASE IV

PARAMOUNT PRESENTE "PHASE IV" avec NIGEL DAVENPORT
MICHAEL MURPHY · LYNNE FREDERICK
Ecrit par MAYO SIMON Produit par PAUL B. RADIN Réalisé par SAUL BASS
UNE PRODUCTION ALCED · TECHNICOLOR · UN FILM PARAMOUNT DISTRIBUE PAR CINEMA INTERNATIONAL CORPORATION

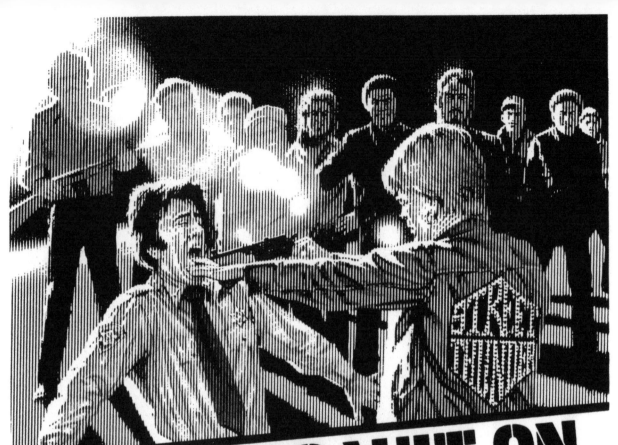

A WHITE-HOT NIGHT OF HATE!

ASSAULT ON PRECINCT 13

R Distributed by

Theatre

TV GUIDE

The Royal Wedding: What It Means To Us

BY ANTHONY BURGESS

—Plus a Guide to Watching It

Page 2

400 Local Programs
July 25-31, 1981

·AMSEL·

Prince Charles and
Lady Diana Spencer

0 714355 30

37

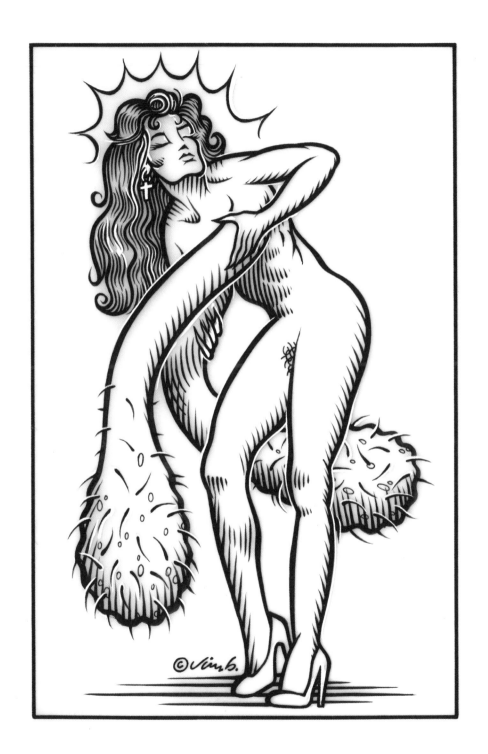

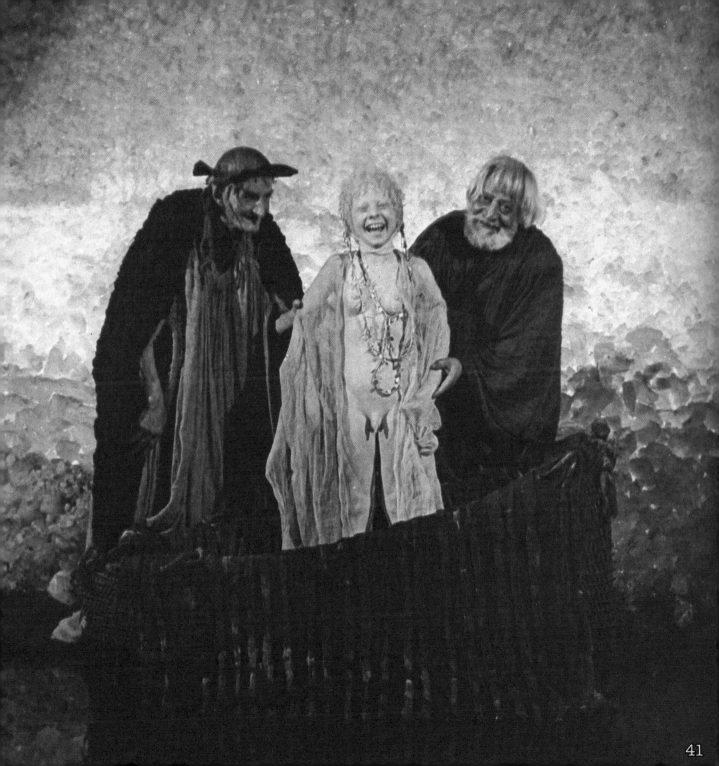

my heart to my mother,
my cock to the whores,
my head to the hangman
-Genet

In 1972, Roger Manvell, a Director of the British Film Academy, acting as general editor of *The International Encyclopedia of Film*, writes rather warningly about "incessant voyeurism" in cinema. He tends towards morality (the frightened kind), yet muses correctly about voyeurism's horn of plenty. Narrative prolifically pieces together a story, and we-the-voyeurs argue about how-and-what we see, with subtext, meta-text, aura, *force majeure*, in-your-face, and other interpretative flogs urging us on; the point is, narrative mandates servile (i.e. obedient) images.

The International Encyclopedia of Film is meaningful for personal reasons. It is a large, tactile book, of a time when people kept libraries. It was given to me when I was 10 or 11 and is the origin of my "hermaphro chic," as an enunciator of gender-and-symbols. Specifically, there is a color plate from *Fellini*

Satyricon (1969) on page 214. This was years before I watched that movie and the *Encyclopedia*'s caption makes no mention of a child hermaphrodite.

Understand, all I saw was a luminous wall of stone and two grinning geezers holding a young "thing"--adorned and robed, but with the garment pulled back leaving "it" exposed. The "thing" has a whitish-blonde perm; there are girly buds on its breasts and center is a hairless peepee-escargot. Facial details like squeezed eyes and agape mouth convey blind, ecstatic defiance, birth-fresh mystery, inexplicable nausea. The scene freaked me.

And hermaphro chic has freaked cinema. As spectres go, this one is industrially polymorphous, and traffics from magical being to evil incarnate, with revolutionary ambiguities fizzing between. More than an "other," the hermaphrodite is an "others," a minyan of overabundance. Per this exciting notion of a "group body," I wrote to an editor,

The idea behind connecting hermaphro chic with pre-teen personae is to celebrate dynamic, impish gender

expression. My choice is to examine "innocence" relating to pre-sexual awakening, but this is a full sensuous innocence, in a ferment, conditional to a fault: it is more "condition" than person. It affects the tribulations of growing up. Hermaphro chic is junior high's secret. One can say innocence is inherently hermaphroditic and the ease child performers have in exaggerating male-and-female manners shows off the hermaphro tendency.

As actors age up, gender in movies becomes more aimed and intentional (and final), ranging from an identity gambit like *Boys Don't Cry* (1999) to the bug-outs of *The Rocky Horror Picture Show* (1975), each trading towards destination and discovery. It is precisely the scarceness of self-determinations among pre-teens that gives both a more natural and supernatural quality to their boy/girl mixologies, for example, Tatum O' Neal in *Paper Moon* (1973), or Michael Baldwin in *Phantasm* (1979).

One can attribute extreme hermaphro'ness to filmmaking itself.

CATHY

Basing off yin/yang shuffles of interior-and-exterior vectors, we coordinate exhibistentialism, the merging of angst (existentialism) and spectacle (exhibitionism) into "film totality," or subjective *mise-en-scène*, which conditions narrative into an uncanny gender that contains, objectifies, worships both sexes.

But before beauty, let's get with horror. Horror is part of Freud's definition of fear, proposed as a binary of Horror and Veneration. Beasts, bogeymen, and Medusas are stuffed with our awe, without which, fear is specious. As we checklist hermaphro-monsters, including Charles Napier as Apollo in the *Star Trek* episode "The Way to Eden" (1969), John LaZar as Z-Man in *Beyond the Valley of the Dolls* (1970), Sondra Locke in *A Reflection of Fear* (1973), Jackie Earle Haley in *Day of the Locust* (1975), Richard Lynch in *God Told Me To* (1977), Felissa Rose as Angela in *Sleepaway Camp* (1983), and James Lorinz by the end of *Frankenhooker* (1990), we leave room for adoration.

No doubt the child hermaphro of *Fellini Satyricon* was monstrous. I dreaded the

page that showed me it. Like the whisper of an axe, it castrated with softness and whiteness and littleness, lacking everything I wished. I so negatively identified with this atrocity of limpid meat that involuntarily, a muscle of worship stirred. Soon to bulge when I encountered a bloody-smeary pictorial in *Fangoria* magazine about *The Brood* (1979).

While the brood kids are technically gender-neutral, they evoke masculine/ feminine traits, from monkey- mischief to fashion sensitivity. Their look, much like the *Fellini Satyricon* creature, is "hyperbolically white"[a distinct feature amid *The Bad Seed* (1956), *Village of the Damned* (1960), *Kill Baby Kill* (1966), the "Toby Dammit" sequence in *Spirits of the Dead* (1968), and *Blade Runner* (1982)]such that, a "blondie" superfetation connects hermaphro with perfection, purity, cruelty, demonology, Aryanism, replicants--as though child- like blond power shall exceed either sex or triumph over any situation. More fecund than the obstetric gore, is the

premise of the brood's sleeping anger-- similar to the motives of atomic ants or giant grasshoppers or pissed-off frogs-- the kids are revenging injuries against the womb, the environment.

1979: a seriously amazing time. You have the mother integrity of the 1970s "rediscovery of cinema" nourishing the art/trash twine--i.e. SuperTrash-- that went on to craft the 1980s. The transition from the '70s to '80s is about staging formal exaggerations that "coax" substance. Movies like *Alien* (1979), *The Warriors* (1979), *American Gigolo* (1980), *Midnight Express* (1978), are breakaways of commercial indulgence, and *The Brood* is part of this van.

My study stokes from Soren Kierkegaard and Camille Paglia. Paglia's obsession with Apollonian/Dionysian (Day/Night) warfare and her praise of the androgyne are foundational hermaphro chic. She thinks big, stating, "...free movement among mood states automatically opens one to multiple sexual personae." She likens creativity itself to a continuum of male/female

OVERCOATED MIDGET CITIZENS INSIDE **Czechlets** TINY HUMANS 12 PEOPLE *Czechlets*

antiphony: "The shaman is an archaic prototype of the artist, who also crosses sexes and commands space and time." She notes embedded hermaphrodites like Teiresias from *The Odyssey*, "... an old man with a long beard and pendulous female breasts." I defect from Paglia's mojo when it comes to applying hermaphro.

She prefers the "androgyne"--i.e. the effete teste, the butch clit. My approach is more sci-fi fantasy, focusing on a cyborg struggle-and-flow between male-and-female "parts," as I believe gender to be a "buildable" program, of raw/polished, intuited/forced, appreciated/ loathed components. Puberty is the mangler and only monsters are perfect. I learned from a crazy bitch that Godzilla is a she. (Check those child-bearing Godzilla thighs!)

From Sondra Locke's book, *The Good, The Bad, and The Very Ugly*, we glean Clint Eastwood modeled his voice after Marilyn Monroe. I challenge anyone to study Richard Lester's *The Ritz* (1976) and not agree Rita Moreno is being copied by Al Pacino in *Scarface* (1983). Throughout the '80s we meet multi-specimens of a tough guy proving he can be "the hot bitch"--e.g., Patrick Swayze in *Road House* (1989), Michael Pare and Willem DaFoe in *Streets of Fire* (1984), and Bruce Willis in *Die Hard* (1988). Indeed, there is immediate inconsistency about any "identity." Identity explodes on contact.

Epigrammatically, "every deal you make with yourself is instantly invalid." There is safety in wonder and by breaking the

[continued on page 54]

45

47

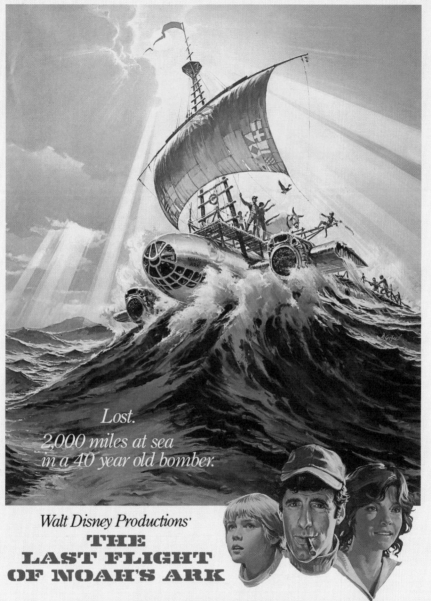

Lost.
2,000 miles at sea
in a 40 year old bomber.

Walt Disney Productions'
THE
LAST FLIGHT
OF NOAH'S ARK

Starring **Elliott Gould, Genevieve Bujold, Ricky Schroder, Vincent Gardenia**
Co-starring TAMMY LAUREN, JOHN FUJIOKA, YUKI SHIMODA
Story by ERNEST K. GANN · Screenplay by STEVEN W. CARABATSOS and SANDY GLASS & GEORGE ARTHUR BLOOM · Music Composed and Conducted by MAURICE JARRE
Title Song "Half of Me" Lyrics by HAL DAVID · Music by MAURICE JARRE · Co-Produced by JAN WILLIAMS · Produced by RON MILLER · Directed by CHARLES JARROTT
TECHNICOLOR® Released by BUENA VISTA DISTRIBUTION CO., INC. ©1980 Walt Disney Productions

G | GENERAL AUDIENCES
All Ages Admitted

PRINTED IN U.S.A.

800063

49

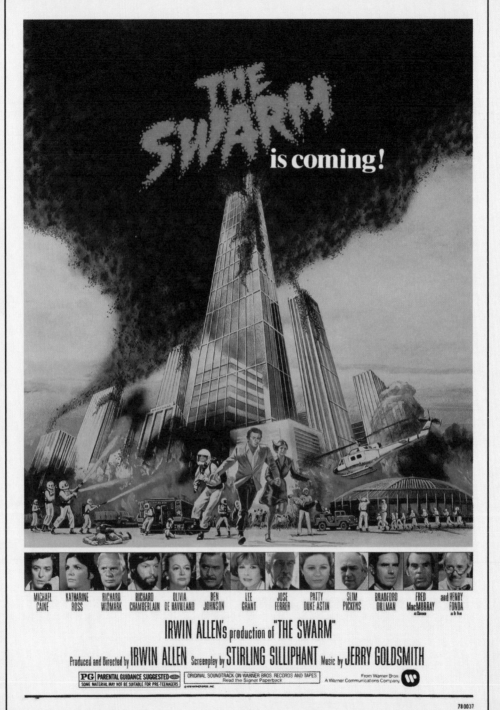

TOMAHAWK MISSILE IN FLIGHT

DESERT STORM

COALITION FOR PEACE

GEN. POWELL & SEC. CHENEY

CARPET BOMBING

male and female together, we discover parts.

'79, Chicago area, on Western Avenue off Devon, a kinda run-down but still classy movie theater, I cannot remember the name. It had a layout like the Varsity in Evanston. Overhang marquee, sizey lobby, carpeted staircases, big room. So I am 12 going on 13 and my interests are movies, comic books, and my bike, a Torker. An appendicitis, a "plumbing" complication thereafter, and a really bad elbow cyst, have busted up my baseball career. Grit and fantasy are my whole deal now, and I get them via the tactility of books, crank of my wheels, and cinema's grainy glowjob. My gang is me and a few other guys. We're into the same stuff. Movies that are violent and awesome. Comics that are inked with panache. Riding around strange neighborhoods. We don't fight other gangs. We beat up ourselves. Ray is kinda the alpha. We vie for his radar. Like, who-does-he-want-for-his-best-friend? Ray's interesting. Not a jock, but consistently aggressive about anything. He bikes like he's flying. His real dad got him into ZZ Top. On Ray's visits they shoot handguns. Ray's room is like the dark side of the moon. His aquarium has these crater walls and two "werewolf" fish that murder other fish (or you could say they combine killing and eating into one move). Ray's okay at drawing Conan guys. His older sister is a hot lady who thinks the guy in *The Warriors* on roller skates with a switchblade who gets spray-painted in the face is cute. Tonight Ray and I are dropped off at a double-feature we're excited for, *Prom Night* and *Phantasm*. This is one of those theaters where kids get into R-rated movies, we are terrifically pleased. *Prom Night* is first. It's a dark movie, like literally a lot of darkness. I remember people killed in a van and a projectile, decapitated head and disco music. It's a depressing movie. I'm starting to notice these slasher movies are emotionally not just about slayage. Some kind of unhappiness is on parade, one that is ashamed to be a major bummer, and hides in death vomit. There's a break

DIMEBAG CHILD

before *Phantasm* starts. Time between a double-feature is special weird time. Now I'm not going to say much about *Phantasm*. There's probably no finer movie for a 12- or 13-year-old boy to see. When we came out we were happy and I believe, a little different. Ray said it. Referring to Michael Baldwin, the spunk of that movie, Ray said, "He was cool. Like us." As crazy as the story is, we are not transported because we are "there." In that clobbered-by-puberty world, that I-have-a-crush-on-death zone, that condition of excitable morbidity and innocent trespass, *Phantasm* conveyed those "nobody-will-ever-explain-to-you" feelings.

As I purr, I am blown by quantum multiplicities. The sphygmic buzz of life's possibilities! I know little except a man, Max Planck, explained energy radiates in units of discrete pulsation called quanta, and alternate realties are staging in the continuum. A roommate told me James Joyce's *Ulysses* is a "literary emanation" of Planck's quanta--an explosion caught in the act of being the universe.

GRAND MOFF TARKIN

8 • © 1977 20TH CENTURY-FOX FILM CORP. All Rights Reserved.

I absolutely buy multiplicity. Two things convince. One is multi-ball in pinball, and two is suspicion that "past-present-future" is one word (which echoes to the original *Trash*, where "sex-and-violence" is uno thang). However, multiplicity is also the ultimate invasive species. It makes you want to die in waves of "what if?" What happened? Who were you? Unpleasant stuff. Then, a mood or instinct untwists. You are aimed, depression decapitated.

That same friend uses quantum theory to motivate totally opposite--*toto caelo*--philosophies into "empathetic 69s," where, for example, the hard materialism of Marx, and Hegel's cosmic shapes, agree to agree. Paradoxes make us brave. In order to be smooth, there must be a rocky road of quanta. My paradox is SuperTrash.

The simple, chaotic truth of the 21st century is that it is hard to tell the difference between art and trash. The goal of SuperTrash is to increase the difficulty by showing art and trash cannot be unless both are; as Whitman said, "lack one lacks

both."

When playing the concept-game, it's stimulating to realize the literal is misleading and the figurative is premature. For example: "Eat Shit And Die." More apt would be: "Eat Shit And Throw Up." Correspondingly, SuperTrash is not about a triumph of trash or the notion that art is enhanced trash (a legit notion). Rather, SuperTrash is an inconvenience of wordsmithery necessitated by a crippled zeitgeist, specifically a 21st century still unaccounted.

The "groovy dystopia" take on the estrangement caused by technology is, according to Baudrillard, about how "each individual sees himself promoted to the controls...in a position of perfect sovereignty, at an infinite distance from his original universe." This "sovereignty" is an ambition to reincarnate as a blind egg of media. Media has evolved from box televisions and hammy prosceniums into a sphere--a.k.a. the mediasphere. The market is the message. Signals are commodities. In the mediasphere constant surgery on human personality is underway. It does not matter whether or not the patient recovers.

Perhaps the crucial point is not that the rise of the machines has made us connectivity-slaves, but that the machines have taken over the job of rugged individualism. What is rugged individualism except the assumption that you do not need anyone. "Don't worry about that guy. He can take care of himself." Many attempt it, but it is a mythical, farcical expectation.

Maybe that is why we are dumping our "job"-- to be self-imagined (if not factual)-- onto the mediasphere, which is to say the "presence" of gadgetry is the reification of our presence and proof that human relational interiority is a product. Instead of the machine's addicts and users, we are their fans and followers. Thus the defeat of soul search by search engine, the entrapment of thought and expression by technology.

SuperTrash is a way of breaking with such a world. We imagine a stubborn people worshipping concepts as they would fire, liberated by spontaneous hunkering, willing to interpret the death of God as the silence needed to make

[continued on page 59]

56

HITLER'S INFERNO

in words, in music

MARCHING SONGS OF NAZI GERMANY

1932-1945

contents

Adolf Hitler speaks in Rome. 1937
The crowds cheer and sing, "Deutschland Uber Alles"
The Nazi Storm Troopers sing, "Die Fahne Hoch" (Horst Wessel Lied)
The Nazi Storm Troopers sing, "Heil Hitler Dir!"
Paul Joseph Goebbels introduces Adolf Hitler. 1934

Adolf Hitler speaks in Vienna. 1939
The Nazi Storm Troopers sing, "Heil Deutschland"
The Nazi Storm Troopers sing, "Wenn Die S.S. Und Die S.A. Aufmarschiert"
The small Berlin school children sing, "Die Jugend Marschiert"
The defendents, (Goering, Hess, Von Ribbentrop, etc.) plead "Not Guilty"
 at the Nuremberg War Crimes Trial.

Never before has this shocking material been heard in the United States. Most of these songs and speeches were taken from German radio stations after the war. Their joyous quality is frightening, when one thinks of the murder and destruction that followed. It must never happen again in the civilized world.

NARRATION BY BILL FORREST

God meaningful again. Which relates to tsimtsum, the idea of God's voluntary self-exile. Again, the idea of a "periodic" God.

In this realm of things-as-they-emerge (even more so cultivable when they submerge), there is awareness that traditions and transgressions co-operate in the Neo-classic sense of following rules to break rules if not laws, relating to possibly the most influential idea upon my life: Jean Genet's Art is Crime.

The Nazis understood the power of conformity as aesthetic. The policy of *gleichschaltung* (literally, "coordination") placed importance on cultural as well as political conformity. This commitment towards art, if you will, is why Nazi design retains impact. They lost the war but won the fashion show. As recently as yesterday, shaggy comedian Russell Brand got tossed from a *GQ*/Hugo Boss party when he reminded people that the house of Boss dressed the Teutons up real tight.

Yes, art can be crime. And art can be caught, can be outed as committing or abetting a wrong. Yet can still be unpunishable, beyond judgment in the sense that art is fundamentally unspecific and remains subjectively, dialectically open to future minds. In this quantal way, art deems judgment and punishment to be deficient torments.

Art has developed in competition with religion and reincarnation and eternals, heaven and hell. Perhaps art has immunity to existence, and partiality for disruption. Freud says every act of art is a bid for power. Orson Welles described filmmaking as revenge against life. An honest artist encores the dark side and feels some love for the tumult glorified by creativity. Genet's not just saying to make art is to commit crime--for example, William Friedkin risking murder charges to get the car chase in *The French Connection* (1971) or caballing with mobsters to film *Cruising* (1980); no, Genet is suggesting there is an immanently criminal desire or better yet, criminal instinct, that allows art. Mishima calls literature the moment that author and reader unite as accomplices "in a crime of the imagination."

Historically books dealing with genres

of Xploitation were movie review zines, usually with a retro fetish, typically gorehound. The totipotent exception was/is *The Psychotronic Encyclopedia of Film* (1983), a book owed hella by many. In the '90s there were some scholastic screeds from U.K. that tediously "addressed" Xploitation. Then in 2002, *Trash* threw a party. It hit the fatal gong and gave up evidence proving what fools in the choir knew: some of the best art pieces and, absolutely, the greatest movie posters of the 20th century are Xploitation-filled.

Trash carried with it a neo-grindhouse world. However, I have become needy to tell "my story." My story is quantal. There is a psychotic personal side and an anonymously critical side. Like a World War Dadaist suffering from verbigeration, I'll pronounce "SuperTrash" a bazillion times, hoping that a lost tribe will appoint my chant. I'll lash Art History with SuperTrash, which is a 21st century doppelgangsta of Surrealism. With no blessing from nobody but Lee Marvin, I'll repossess fetish through SuperTrash and improve confusion. SuperTrash is a competition over meaning. I picture a cover sticker of "READ MY MIND THEN PLAY LOUD." I have spent time failing

across the finish line. Veteran publishers call me "existential motherfucker," but maybe I'm sharable.

Cringe if you are an evil nerd. I am your enemy. Victory is not about winning, it's about waging, and perpetuation. The saying about how the more things change, the more they remain the same, is intensely challenging not just because it accepts the immutable as a final condition, but because it asks the gremlins of so-called change to be the apeiron of this condition-- a.k.a. the authority behind it. The question becomes, how much of this "more" or "less" but certainly this "different"--is necessary to produce a "way things are"? What excess? What transformer? How many outer anomalies, inner stirrings must occur before all is was again?

Experience gives the sense that the immutable likes to take on a lot of change before it shows up. Meanwhile we exert ourselves with terrible seriousness "choosing" and "focusing" in acts that defy the quanta. We sense but are never able to see the whole multiplicity at work. This explains why we imagine so many distinctions between seeing and remembering. We look but

[continued on page 68]

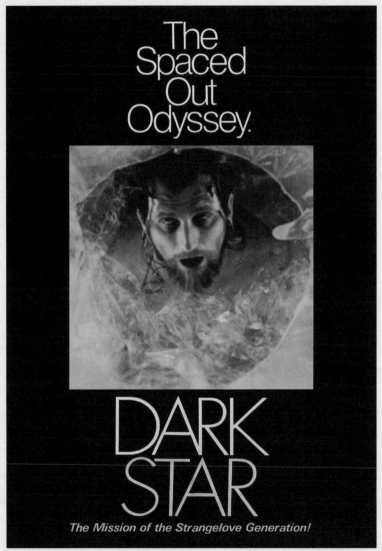

The Spaced Out Odyssey.

DARK STAR

The Mission of the Strangelove Generation!

Bryanston Presents • A Jack H. Harris Production • DARK STAR • Starring Dan O'Bannon and Brian Narelle • Produced and Directed by John Carpenter
Written by Dan O'Bannon and John Carpenter • Executive Producer Jack H. Harris • A Bryanston Release • Color

G GENERAL AUDIENCES
All Ages Admitted

75/16

"DARK STAR"

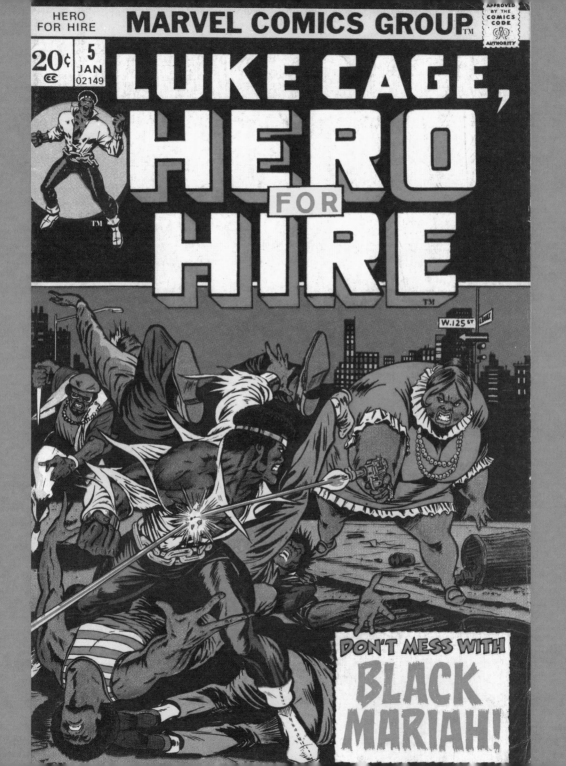

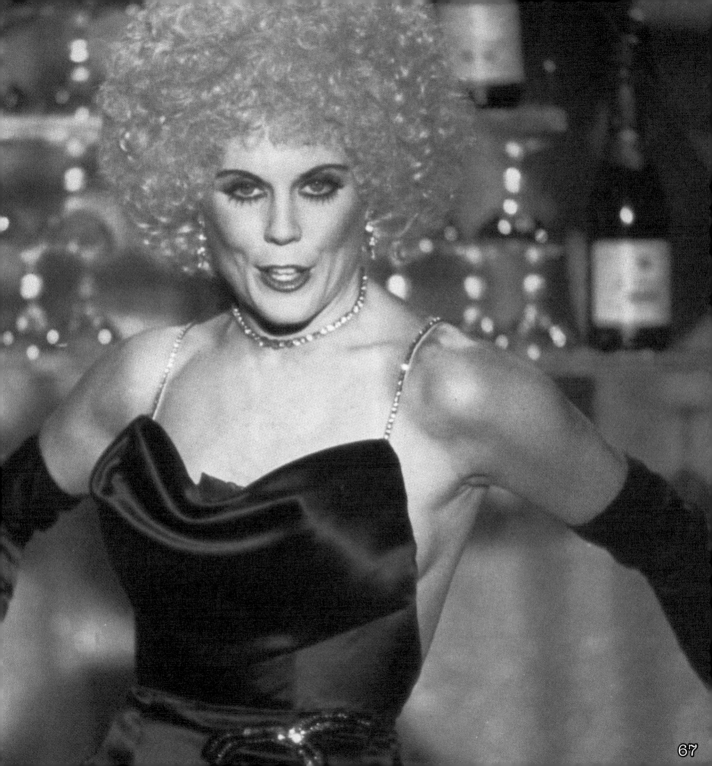

cannot really see, therefore we remember.

Now, sharpies are wondering, what is this? This guy starts ass-kissing quantum multiplicities and ends up titty-teething alpha-omega immutables!? Consider this: reality, according to classic Vedanta doctrine is one, hence all plurality is illusion or "maya." To what extent SuperTrash may be such a thing as a quantal, maya-packed oneness will depend on how enjoyable trauma in the form of thought-provoking-juxtapositions can be (juxtaposition being the weaker word for paradox). It's time to slap all the men in the mirror, or as Glenn Frey observed, "Joe Walsh was an interesting bunch of guys."

What could I mean by "On the banks of big other, PSYCHO WANTS PUSSY?" Since Big Other is a ripieno for "hermaphro chic"--punning on the Big Brother implications of being surrounded, observed by Big Other(s)--I'll answer that this means everyone is baptized in hermaphro, a watery (Camille Paglia would say "chthonian") mixed sexual identity. It threatens us with pleasure, pain, and perhaps most hostilely, evolution. Despite initiations, despite any brokering of identity, the power of certain reactionary instincts does not abate. In fact, the stuff of sexual confrontation will always live in its own chamber of psychotic SuperTrash. But as Big Other knows, transformation is never complete.

Much of masculine-feminine science is invisible and the mobility of sexual identity is beyond androgyny. Virile femmes and salty queens are not the only campers who tart these woods. We are also brandishing new wave hookers and bad gods. Therefore the symbols of hermaphro must be explicit. Big Other is a registry of fetish, of monsters and accessories, and language: Helen Slater, priestess of the nuclear dildo, *Supergirl* (1984); John Hurt as Asmodeus with vagina forehead, *Spectre* (1977); penis-nosy Dan Ackroyd, *Nothing but Trouble* (1991); Laurence Harvey's macabre visage--totally bloody, cut in half by a teardrop--in *Welcome to Arrow Beach* (1974); James Caan, an eye-fucked Dionysus in *Lady in a Cage* (1964); Richard Burton punking Clint Eastwood: "In your own idiom you are a punk, and a second-rate punk at that,"

(continued on page 80)

DEATH STAR DROID ACTION FIGURE

DEATH STAR DROID ACTION FIGURE The brilliant silver droid of the Death Star is the Empire's battle droid which "mans" all the Death Star's mechanical functions during war maneuvers. The Death Star droid is the Empire's answer to **C3PO.** A shiny silver in color with dead black eyes, it has movable arms and legs for true to life battles. This droid is detailed & 3¾" high #24222/$2.95

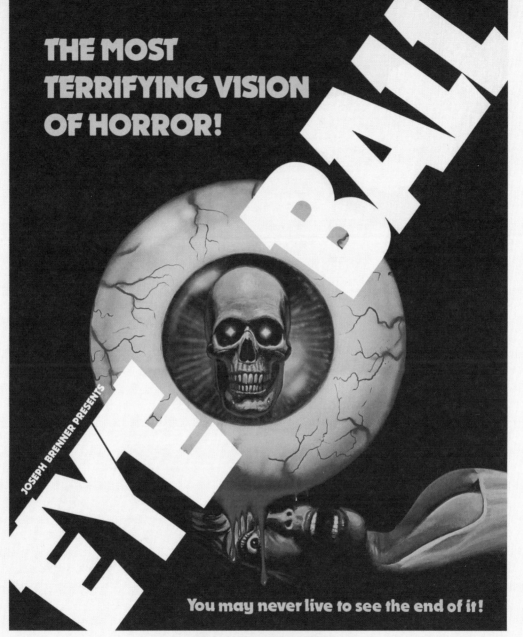

THE MOST TERRIFYING VISION OF HORROR!

JOSEPH BRENNER PRESENTS

EYEBALL

You may never live to see the end of it!

JOSEPH BRENNER PRESENTS

"EYEBALL"

Starring
JOHN RICHARDSON · MARTINE BROCHARD · INES PELLEGRIN · SILVIA SOLAR · GEORGE RIGAUD
Directed by UMBERTO LENZI · Executive Producer JOSEPH BRENNER
A JOSEPH BRENNER ASSOCIATES, INC. RELEASE · IN COLOR

After you've tried everything else...

...TRY

Sex WITH A Smile

Starring
MARTY FELDMAN Co-Starring DAYLE HADDON · SYDNE ROME · BARBARA BOUCHET
Produced by LUCIANO MARTINO · Directed by SERGIO MARTINO · A SURROGATE RELEASE

R RESTRICTED

RECO

TLP 1

NEGRO PRISON SONGS

MISSISSIPPI STATE PENITENTIARY

work songs and blues recorded edited and annotated

ALAN LOMAX

ORIENTAL SLAVE GIRLS IN BAMBOO CAGE
A Sure Stopper for Lobby or Store Window!

Illustrated below is the bamboo cage in which one or more Oriental beauties, smuggled into old San Francisco, are displayed. The girls are for sale to the high-

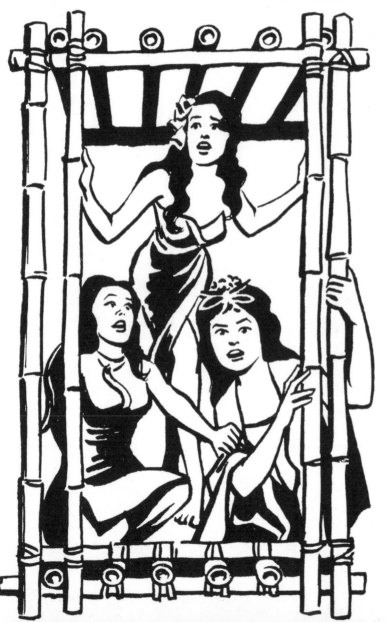

est bidder. Such inhuman and illegal practices were prevalent during the very early part of the 1900's in the secret haunts of Chinatown.

A similar slave cage, constructed locally, would be a sure stopper as a lobby or store window stunt. If you cannot obtain bamboo, have your artist simulate the bamboo shoots on beaver board. If an Oriental girl is not available, have a white girl made up to look like one. She is to occupy the cage during peak show hours. Tie-in copy should read:

GIRL SLAVES FOR SALE —
SEE "CONFESSIONS OF AN
OPIUM EATER!"

76

SHANG-CHI'S BASIC RICE RECIPE

Quick-cooking rice is available at the supermarket. It cooks in only a few minutes and is very easy to make. Follow the instructions on the package. But if you are *not* using quick-cooking rice, follow this basic recipe.

> 1 cup rice
> 2 cups cold water
> ¼ teaspoon salt
> 1 tablespoon butter or
> margarine

In saucepan, combine rice, water, salt, and butter or margarine. Bring to a boil. Lower heat to medium low. Stir with fork. Then cover pan and simmer 12 minutes or until all liquid is absorbed.

They didn't smoke grass.
They didn't take the pill.
They didn't do their own thing.

They went to college in the Fifties.
They pledged fraternities.
They celebrated Hell Week.

They were the buttoned-down, bottled-up generation.
And sometimes they exploded.

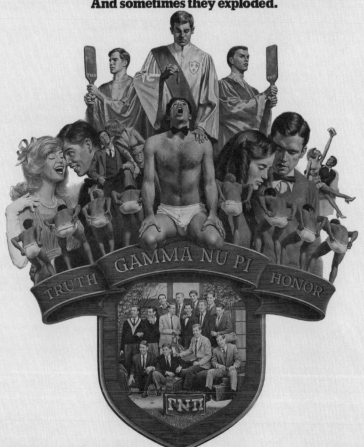

PARAMOUNT PICTURES presents

"FRATERNITY ROW"

Starring PETER FOX GREGORY HARRISON SCOTT NEWMAN NANCY MORGAN
WENDY PHILLIPS Special Guest Star ROBERT EMHARDT
Featuring Music by DON McLEAN Written and Produced by CHARLES GARY ALLISON
PG PARENTAL GUIDANCE SUGGESTED Directed by THOMAS J. TOBIN IN COLOR A PARAMOUNT RELEASE

77/51

78

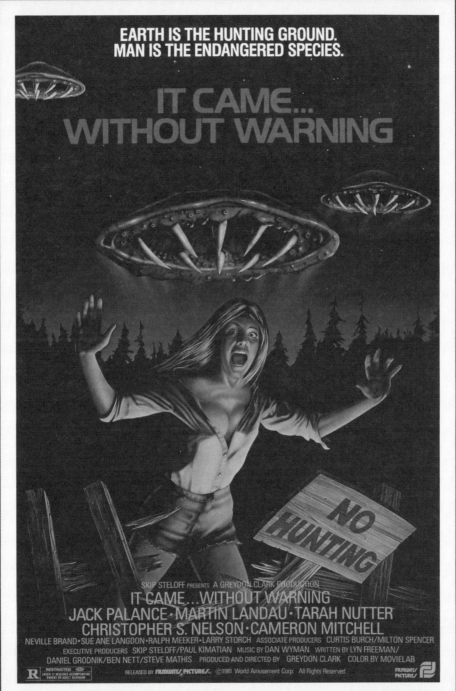

Where Eagles Dare (1968).

"All consciousness is, basically, the desire to be recognized," says Camus, or more jabberwockily, the sound of her dress said it too. Camille Paglia, an intellectual fright wig, asserts, "It is woman's destiny to rule men." I respond, "No Camille. The universe maybe, but not men." Furthermore I wonder if men will become the memory of what women used to be. Certainly this is a provocative thought, one that engages the hermaphro chic of this work. You do not have to be a Coleridgean poet with "flashing eyes" and "floating hair" to sense gender is adrift, and an isocephalic reckoning is lining us all up to be stupendously level.

Just as SuperTrash argues for equipollence between art and trash, a co-identity of man-and-woman plays at oneness, per skills such as belong to the mad scientist, the zen archer, or

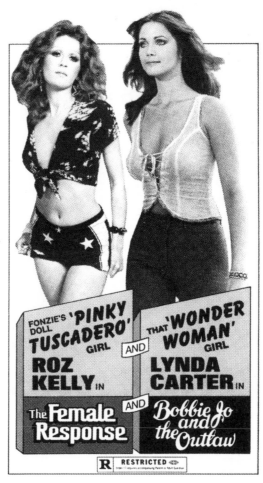

the uroboros itself. I love the definition (not mine) that the truly great is what is accessible to all. For gender to be great there must be hermaphro. The feminine and masculine were not just made for each other, they were designed to be each other.

Paglia references another scholar named Anthony Storr who says, "At a very primitive level, all mothers are phallic." This adds a notion of what penis envy might be and disputes the Freudian "I wish I had one of those." Instead we face a more vaporous boner. A penis encrypted in and expressed by mothering. I understand it as a suspicious leadership, an indirect bullying, twisting around me, to which I add, "Mom I love you." Paglia puts it, "The serpent is not outside Eve but in her."

Having moved from San Francisco after sixteen years of underground work,

I wrote to a colleague in Pittsburgh at The Warhol Museum, mentioning SuperTrash for the first time:

I'm relocated. Werepad is finito. Passion in Portland is utilitarian. I'm working with a new team of archivists. We're developing an Xploi xhibit called SuperTrash. My thought is: when Warhol passed the filmmaking hat to Paul Morrissey, their scene switched to Xploitation. Is it possible you guys might curate other Xploi brands beside Warhol? With interest gaining around horror, sci-fi, grindhouse, my urge is to snap the hierarchies by disguising the avant-garde as trash. To my knowledge, no museum has made up a major Xploi show.

As an aside, the title *Trash* for my first book was not my idea. The editors picked it. At that time I thought the term "trash" was a symptom of apologia--e.g., dumb conceits like "50 Worst Movies!" "Guilty Pleasures!" "So Bad It's Great!"-- in short, the backhand approach to liking questionable movies. The editors' concession was a conceited subtitle, "The Graphic Genius of Xploitation Movie Posters." Their corporate marketing blended with my beatnik rethink. *Trash* sold. I sermonized like a Dadaist (SexTrash, GroovyTrash, HorrorTrash, etc.). This comedy was 'blessed' by an exiguous word-count. Strangely, for so little writing, many took offense at my mystic attitude. *Trash* was a leap of fetish. It remains unlike any poster book due to its epiphanic sequencing and weirdo language. The truth is I had to stop the publisher from turning trash into kitsch.

I believe there are messages in Xploitation, hidden schools, as in Argento's *Inferno* (1980), where sorcery is written into architecture. Basically my notion is that the 21st century is waiting for the 20th to parlay its signs into a scandal that openly worships contradictions. For this to happen, *SuperTrash* must be brainy yet addled, fun as hellfire, and semantically autonomous (not a *Trash* sequel, but a shout-out to "the new obvious"). The idea in *Trash*--that Hollywood has poached Xploitation--is

no longer news. More fascinating is how slight the effect of this looting has been. Amid profuse remakes, re-issues, re-imaginings, not much trash of value has come forth. Certainly no Xploitation scene has achieved anything commensal to the 1950s-80s. Let's consider Hollywood's failure to reverse-engineer Xploitation.

One reason is the disappearance of the mindset of the children of the '70s. Pre-sensuous, impish, this crew of diablotins tops out circa *The Bad News Bears* (1976), *Over the Edge* (1979), *The Warriors* (1979), and *Phantasm* (1979).

To understand Xploitation culture as it cruised the 1990s, we should remember antinomies between '70s children and the Boomer bourgeoisie, how the radical sect of the former construed the neo-grindhouse mutagens which were turning

MTV, too late for hippiedom, punk, and still not ready for nerd world, this peculiar "in-between" generation is the fetus of *Starsky & Hutch* and Smack [with a nod to Godard's line in *Masculin Féminin* (1966) about "Les enfants de Marx et de Coca-Cola"]. Visually we identify 70's striplings in *Billy Jack* (1971), *Bless the Beasts and the Children* (1971), *The Omega Man* (1971), *The Idaho Transfer* (1973). Blingless, introverted, yet observant, Trash and Art into intimates, while the latter politically corrected the "arthouse" and ass-throated things like the Sundance Festival, the Oscars, *Vanity Fair*, all the while oblivious to millennial tastebuds and a quickening of consumerism.

'70's-stung youth carried a chimerical (and commercial) ability into the 21st century, one that allowed them to rate certain B or even Z movies as A+. Deluged by hallucinatory revisionisms and the

forfeited 'shortcut' of Bad=Good, Bad and Good cancelled each other, and the craze for art-acceptable trash gave quite a good definition to what is immanent in movies: the simultaneous catching of the creative and destructive; the horror of beauty and the joy of ugly; the thrill of despair and the pain of happy; the sexuality of violence and the sunrise of death. '70s lovers stamped a birthmark on "getting" Xploitation.

One more deet about these kids, they exhibited conation--i.e. a mentality of striving. Acts of conatus occur without specific knowledge (cognition) or clear feeling (affection). Conation indicates strange purposefulness, daresay, cosmic instinct. 20th century survivors need SuperTrash to pursue the pleasurable instability at the core of 21st century being. But if Xploitation has moved into SuperTrash, why should it seem quarantined? Because a mediasphere where ALL IS PERMITTED AND NOTHING IS SHOWN cannot continue. Without capable ronin critics crusading to thole and vex

them, today's trash brigade is idle among spoils.

Legions of evil nerds--starting with children of the '80s and proceeding into the '90s--remain in an abyss of awesomeness they cannot fully appreciate or half-understand. The mediasphere has gone topless, bottomless, and insatiably global, usurping individual continuity, replacing sacred knowledge with social network. Some believe the gigantism- and-miniaturism of digital screens is a push- forward, but for me, the solipsistic interiority where appreciation prospers is hemorrhaging beauty sleep.

Without uninterrupted withdrawal and deliberate hibernation, that which "would imagine itself" doesn't stand a chance. Thus we are pinned by a stagnant flow-- i.e. a fabulously loaded mediasphere that indulges us by shifting units of hyper- compartmentalized encounters and prepared discoveries--nulling the could-be breakthroughs of a generation

[continued on page 98]

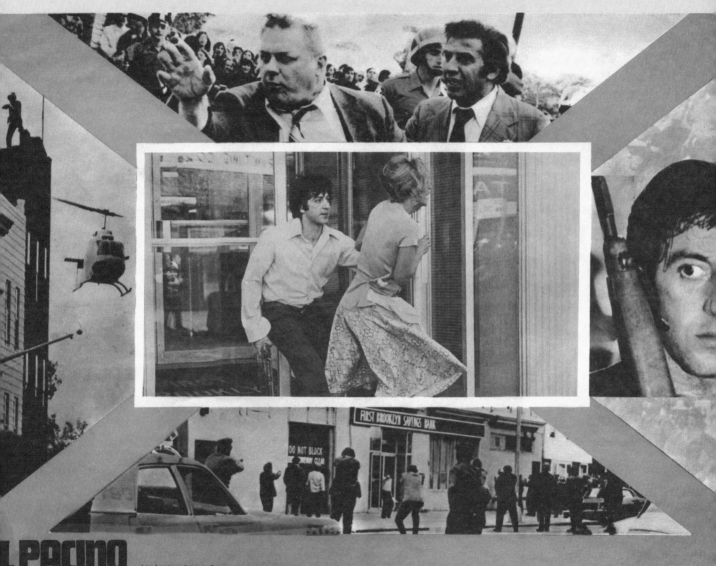

AL PACINO
"TARDE DE PERROS"

UNA Artists Entertainment Complex Inc Production

CON JOHN CAZALE · JAMES BRODERICK y CHARLES DURNING COMO Moretti · GUION POR FRANK PIERSON · PRODUCIDA POR MARTIN BREGMAN

DIRIGIDA POR SIDNEY LUMET · EDITOR FILMICO DEDE ALLEN · TECHNICOLOR® DE WARNER BROS W UNA · WARNER COMMUNICATIONS COM

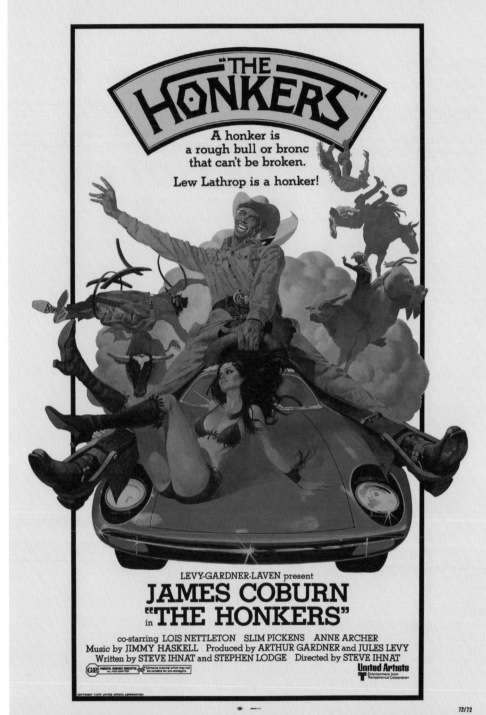

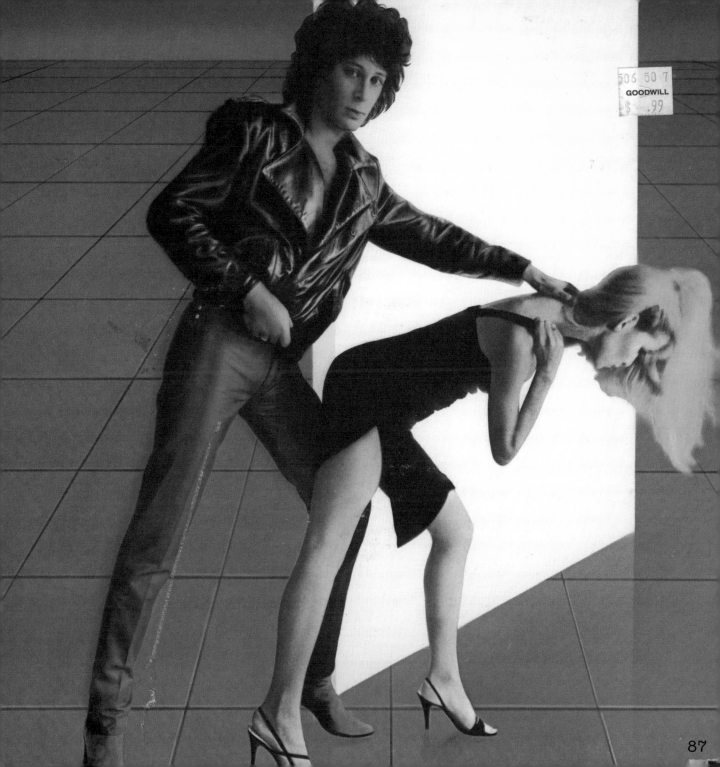

506 50 7
GOODWILL
$.99

87

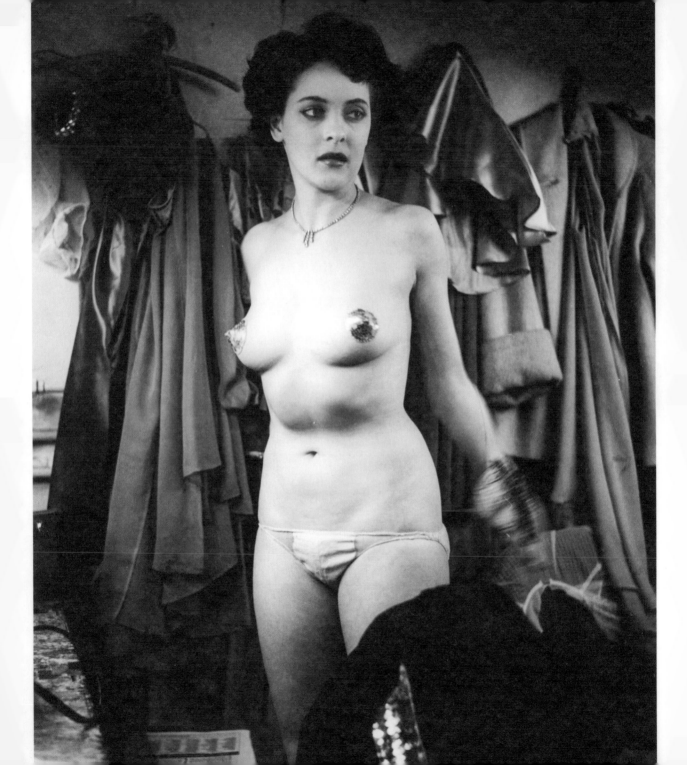

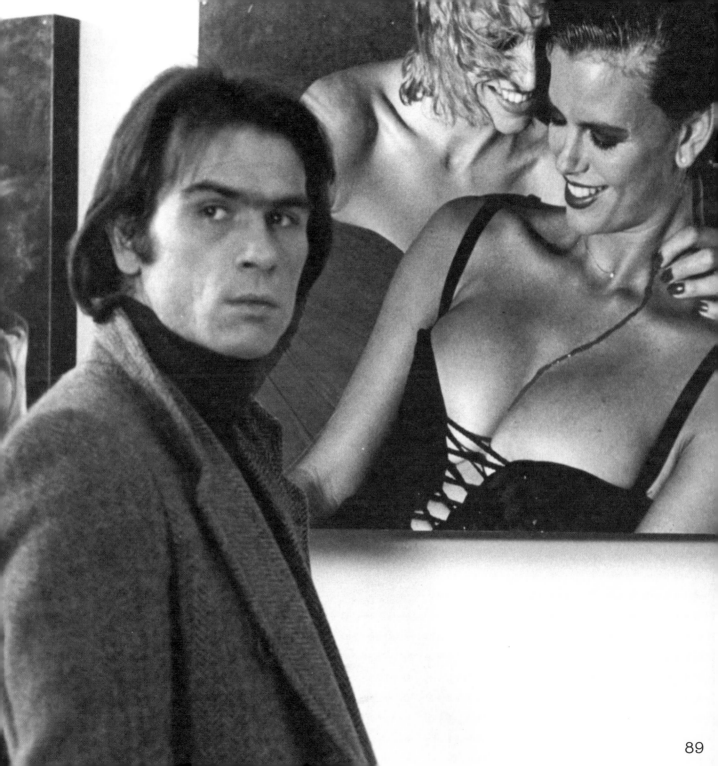

THE CULPEPPER CATTLE CO.

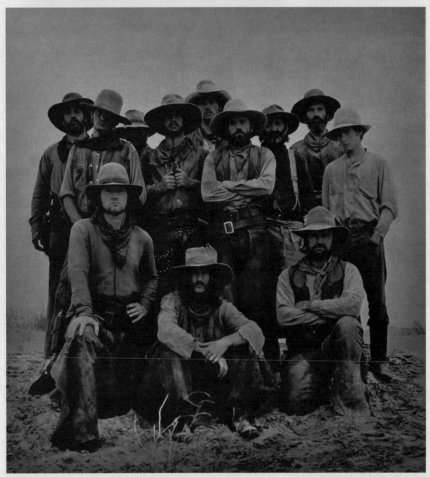

IS COMING SOON

72/88

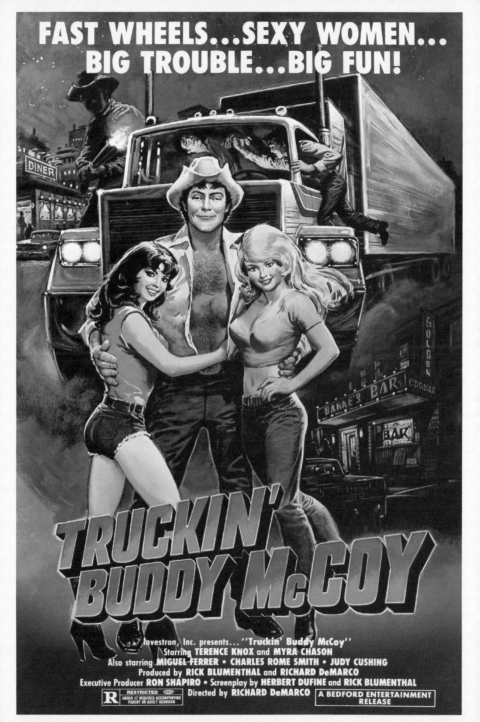

FAST WHEELS...SEXY WOMEN...
BIG TROUBLE...BIG FUN!

TRUCKIN' BUDDY McCOY

Investron, Inc. presents... "Truckin' Buddy McCoy"
Starring TERENCE KNOX and MYRA CHASON
Also starring MIGUEL FERRER · CHARLES ROME SMITH · JUDY CUSHING
Produced by RICK BLUMENTHAL and RICHARD DeMARCO
Executive Producer RON SHAPIRO · Screenplay by HERBERT DUFINE and RICK BLUMENTHAL
Directed by RICHARD DeMARCO A BEDFORD ENTERTAINMENT RELEASE

R RESTRICTED
UNDER 17 REQUIRES ACCOMPANYING
PARENT OR ADULT GUARDIAN

"Truckin' Buddy McCoy"

EDDIE RABBITT

Claudine
Colours

95

and adding a problem of epigonism--i.e. the aping of previous "scenes."

Who can say what is the decider between virtuous emulation and unfortunate reinterpretation? The epigone's habit is to exaggerate his master's voice, and when successful, the result is a suture of dumb-down and lame-up. Because, quite differently from bracketed homage or precise quoting, the tropes of the epigone try to conquer a past. The epigone is a deadly fan, a closeted killjoy, an evil nerd. Take Quentin Tarantino for example--but why blame him? Better to shame all the nipped cineastes for not carrying forth the cinema daddies from whom QT rips off. What is truly creepy is when plundered sources "thank" QT for his avaricious admiration (a far cry from when Hawks panned Peckinpah, Peckinpah slammed Bogdanovich, etc.).

By playing the Shiva/Kali role of destroyer/provider, QT's regurgitations forensically tickle a crippled zeitgeist astride a kleptomaniac's palette. While QT's methods are tight, Tim Burton's, like the mediasphere itself, can be panicky and "too creative." Burton's spongy, goony, yet conservative re-imaginings fit the notion that millennial audiences wanted 20th century latecomers to "fatten" and "wrap up" 20th century greatness (imagine an eating disorder of the group mind declaring, "We hunger for you to vomit!").

Here's a word: gerontomorphosis, referring to adult organisms characterized by increasing specialization and a lowered capacity for further evolution. I think both Tarantino and Burton's oeuvres scream "Gerontomo!"

The third reason Xploitation languishes is because the Hollywood Life--i.e. the odyssey of sacrifice, stardom, groovy self-destruction--has to be cinematically "verified," and that's not happening. Where is Z-Man? Kowalski? Tony

Montana? For most of the 20th century, Hollywood attracted its myrmidons with the promise (if I may crunch down a quote from Nick Tosches) "to bloody virgins and seek detumescence without ruth." After the 1921 Fatty Arbuckle debacle, some vices were discouraged, yet works like Kenneth Anger's *Hollywood Babylon* (1959) and Bob Woodward's *Wired* (1984), confirm the on-going ethea of crack-ups, perverse rituals, premium cocaine, trophy fellatio, secular immortality, etc. (Today we hear of non-disclosure contracts for "entering" Justin Bieber's crib).

Then something "new" started to poison the excess around the time of the O.J. Simpson and first Michael Jackson trials. If we momentarily agree that Black is America's metaphor (Nietzsche reminds us the motive for metaphor is the desire to be elsewhere, different, free), it's perceivable how hierarchical borders between celebrity and civilian spaces have never been more emancipated and confused since these "black" scandals, after which developed the social contract of the internet and reality television, and unprecedented vacancy for shared depravity. By converting privacy into commodity, and removing time and space from between "the event of happening" and "the event of reacting," the demand for immediate gratification is open to the disease of instant judgment.

Cyberware escorts tabu content into public clutches; celebrities stoop to being "real"; civilians scoop familiarities from a range of stars; dialectically, civilian idols are made with the help of celebrity judges. One can follow how such a format is both anti-art and anti-trash, where impact is erased because there is less privacy (real or imagined) to exploit. And what does privacy's abolition have to do with the decay of Xploitation?

Privacy is conducive to reckoning such that only viewers able to contemplate can be disturbed. By refusing the "offer of difference" that occupies between a private experience and a public arena, cyberware repeals our territorial instincts, skills that would otherwise negotiate with media and arrive at a reckoning. If reality television were to transport/disturb the viewer, that would

[continued on page 108]

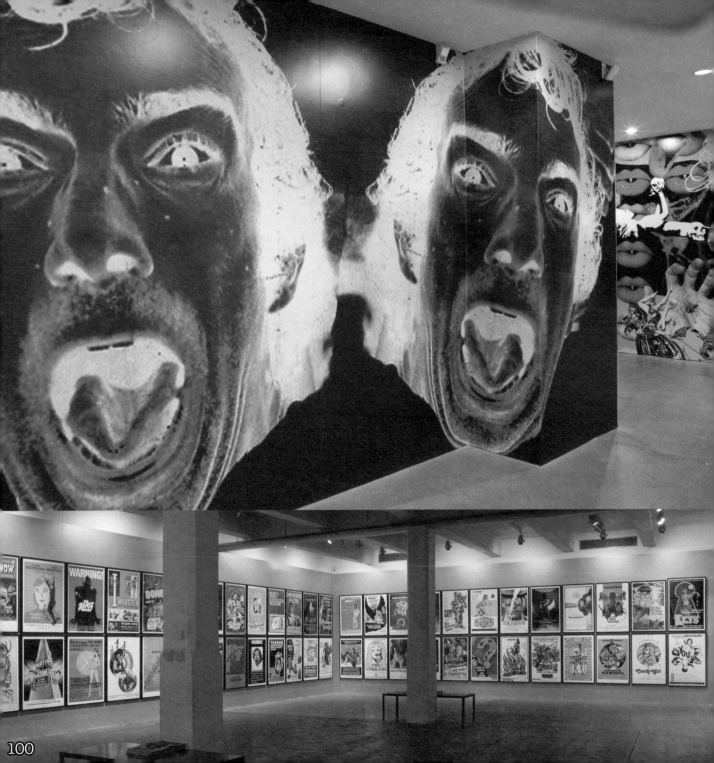

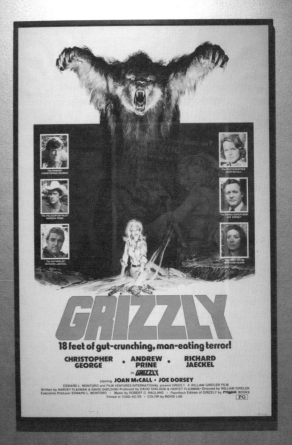

101

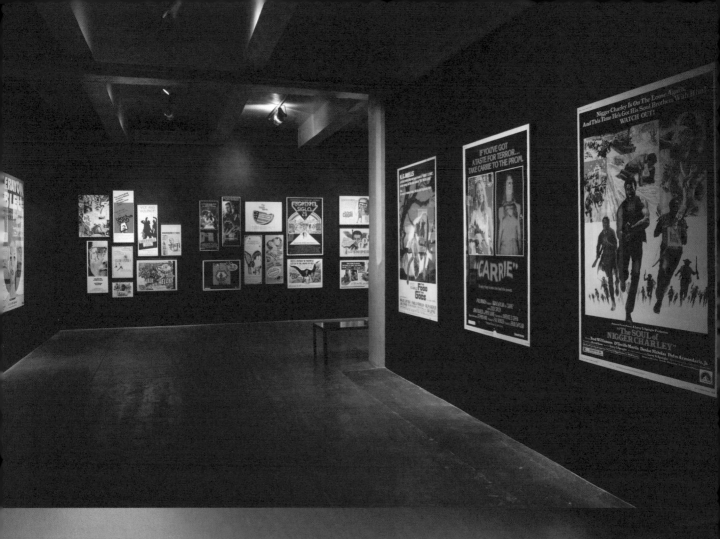
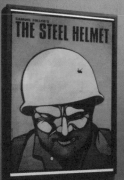
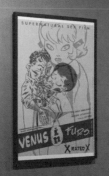

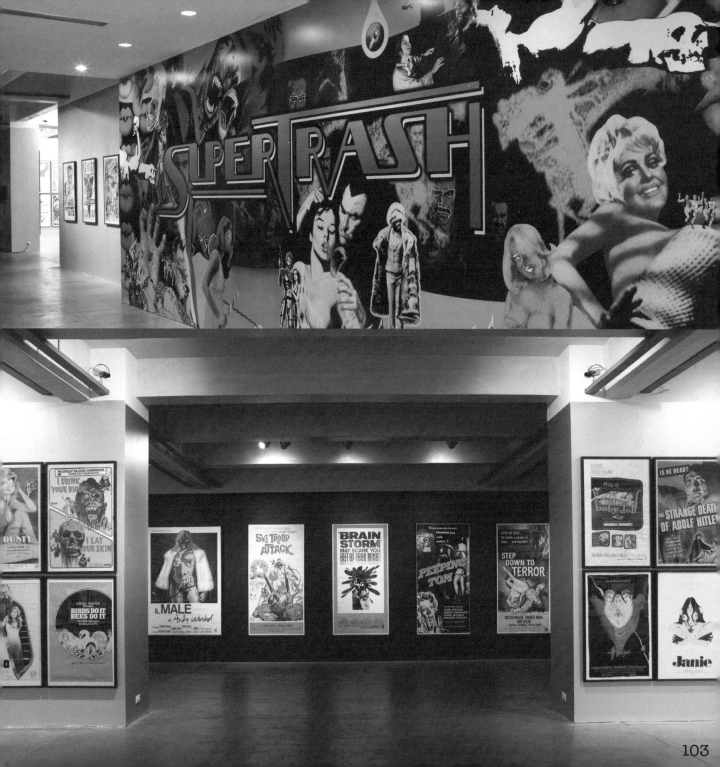

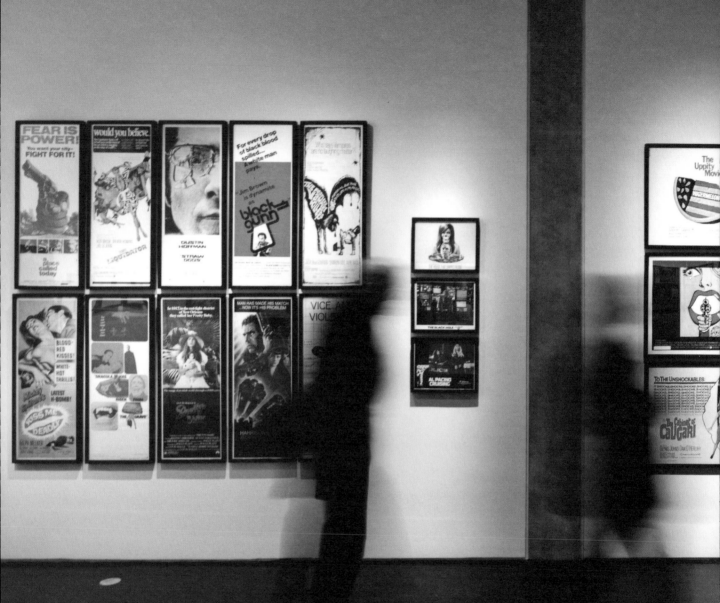

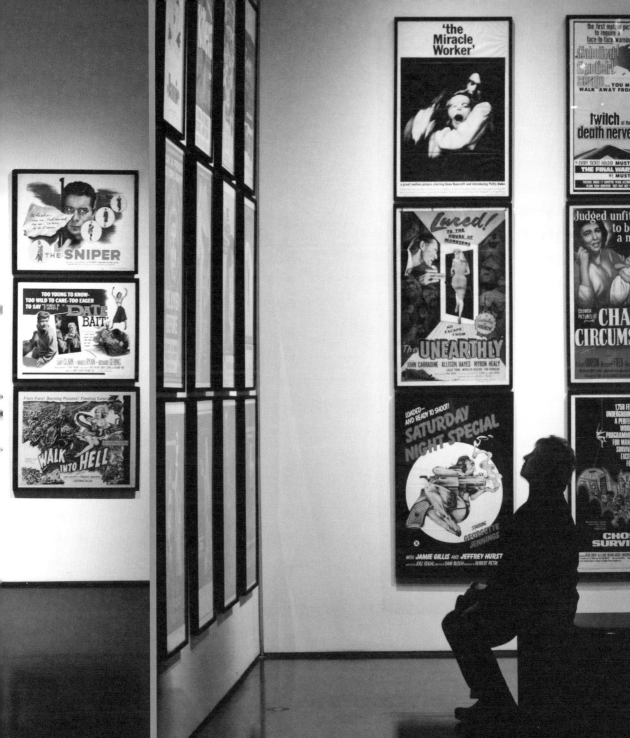

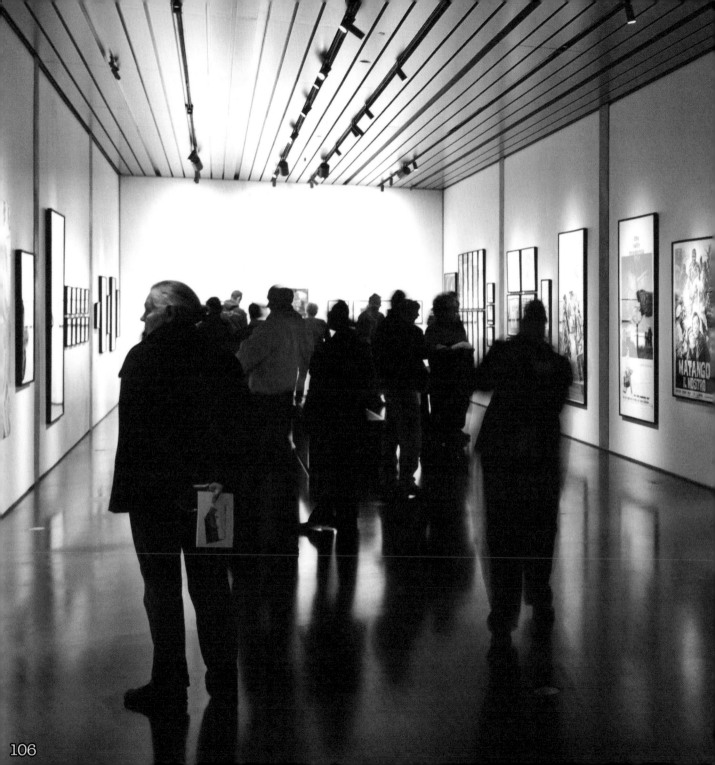

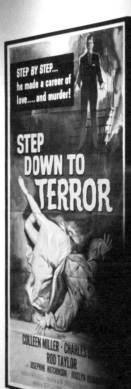

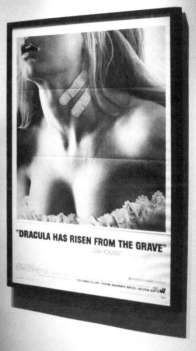

be a violation of its own disposability.

Ultimately this indolent format is non-committal, micromanaging, sheared of second thoughts, and shapelessly vulgar. So it is not surprising that, in the context of the "all permitted/nothing shown" mediasphere, Xploitation can't ponder its job. If anything, Xploitation *must* preserve totems of abnormality, namely, Art and Trash.

Should you be into this aggiornamento, I suspect these remarks may be welcome. I look at hipsters who joined the scene around 2000 and see verminized Situationists. Drifting? No. Mapping? No. Digging? Somewhat. Scurrying? Assuredly. I feel from them an uncaring that cannot be termed apathy, for it is too mysteriously agitated to be just that. It may be theirs is an adaptive, necessary lack of depth. As audience, they are void.

A deadening thought is that while original content persists--e.g., a *per se* valuing of a specific movie--the mediasphere's prolific screens, links, morgues, and archives, have caused what were once migrant, lyrical auras to be fixed into interactively abandoned fragments. This state of "frozen hysteria"

along with piracy addiction supports a society that babbles directions and precisely dictates trends. Like DVDs, people are equipped with extras and commentary, but this meddling does not pander the essential.

If we are located in a "fearful vastness," we need to pimp coordinates of "cinematter." Cinematter is the energy of a movie in another object, as a talisman is imbued by outside powers. When a part suddenly seems more holistic than a whole, or a whole bursts into more parts than previously thought, something immutable is returning to the center of the edge. *SuperTrash* is about finding buoys against dissipation. The raw materials for this project are movie posters. They are the *fieri curavit*, Latin for "caused this to be made."

More than any signage, the movie poster states the 20th century's official surfaces, chthonian innuendoes, and art/trash voodoos. No urge, design, suspicion, desire, crime, fascination, love or atrocity goes unrepresented. SuperTrash is a complicated "Yes" paroled from jails of genre, history and criticism. What we got here is 21st Century Surrealism.

The Werepad sprang from personal motives. In the early '90s I was prematurely washed-up in San Francisco. I had made an indulgent, nihilistic film, *Hippy Porn*, anticipating that my peers might crave a product that clustered Roger Corman, Andy Warhol, and Jean-Luc Godard. They didn't. I errantly went nuts. The 'dark' got free (finally!) in forms of girls and drugs and certainty that no school/ home/job was worth attending. I started not wanting to even see movies in movie theaters.

But I felt that if I located one other guy feeling a like funk, together we could conjure an alternative to the so-called theaters. Enter Scott Moffett. We were *Spy vs. Spy*, two pods in a pea with different mannerisms. He was Satan demure. I was Jew gabby meets Catholic S&M. We worshipped comic books. Scott was into outer space aliens like Lorne Greene. I loved musketeer rockers like Sam Peckinpah. We were hip to black power, he from a bemused Louisiana "country" attitude, I from a "cold and gray" Chicago deal. Together we hung a shingle of voodoo and shared a *sang de art fag* (and did our own stunts).

This piece describing Delluc's *Fièvre* (1921), captures the romance of the Werepad, and the angst under the slick psychedelia that soon became our meal ticket: "A gloomy waterfront den with its hardfaced barmaid, its swaggering sailor-hero and his half-caste wife who crouches dumbly at his feet gazing longingly at a single flower." In other words, true to our hunt for cool and quest for cunt, we starred the streets.

Before we controlled 3200 square feet on 3rd Street in between blackalicious Hunter's Point and the declivity of Portrero Hill, our "scene" started in Scott's apartment on 16th and Valencia around the corner from the Roxie, an ex-porn theater. Scott's living room was our movie theater (with a bar!). Every closet crammed with 16mm's. In the kitchen a stubborn rat and a jar of olives. We sunk in beanbags on incense-dusted rugs. Scott bought prints only a few people gave a shit about. Emotionally speaking, we sucked and fucked cinema.

The Werepad came next. We were the first Bay Area outfit to bring back

[continued on page 112]

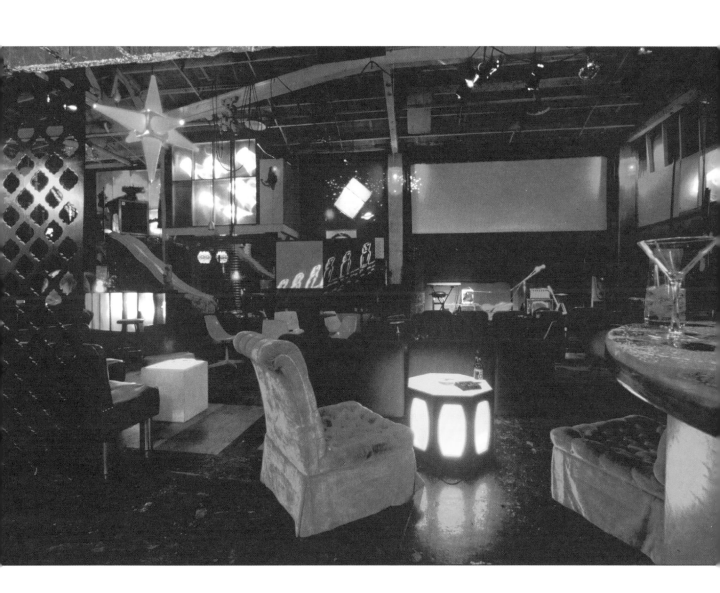

Foxy Brown (1974), I Drink Your Blood (1970), Impulse (1974), Shanty Tramp (1967), Frogs (1972), Black Gunn (1972), Phantom of the Paradise (1974), Zardoz (1974), The Love-ins (1967), Candy (1968), The Car (1977). To distro a video or DVD is one thing, to haul around film prints is another altogether. We laid for "aura." We were the monkishly blissful antitheses of evil nerds. There was no internet culture yet. Our web was the underground. We lived according to what Jerry Lewis said when he said, "Film, baby."

I imagined all kinds of pastiches--let's combine The Alamo (1960), Assault on Precinct 13 (1976), Zombie (1979), and Dr. Strangelove (1964) into a fresh bummer power! Because if there was one movement in cinema I wanted to reanimate, it was the "bummer power" of the '70s, which was sort of christened by Easy Rider (1969) and refined in Vanishing Point (1971), Welcome Home Soldier Boys (1971), Get Carter (1971), Taxi Driver (1976), Lifeguard (1976), Sorcerer (1977), Who'll Stop the Rain (1978)--continuing through neo-bummer-power flicks like Wonderland (2003), which, although lacking the clarity of a self-righteous era (e.g., A Decade Under The Influence), musters adequate male mystique to herniate its corruption.

Bummer Power is a better epigram than "Cinema of Loneliness." Bummer Power is not lonely, it is shared. It juices the pathos of our plasticity and the durability of defeat with regards to the ultimate sharing of ecstatic death: death as the vanquishing of difference, ego, gender, which is why Alan Ladd's sharply hermaphro flinch-face at the end of The Great Gatsby (1949) convinces me the ecstasy of death is queer. (I recall Mishima saying, "Any confrontation between weak, flabby flesh and death seemed to me absurdly inappropriate.")

As Genet advised Art to be Crime, we add that long-term crime takes commitment. It was with wounded bewilderment that the Werepad hustled Frisco for years and made all sorts of dinero from underground private parties. Most of the events were epically meaningless. We respected the drill. Took the risk. Collected cash. Scrubbed and mopped. And used the $ to shoot film. I was trying to be disciplined in

112

[continued on page 114]

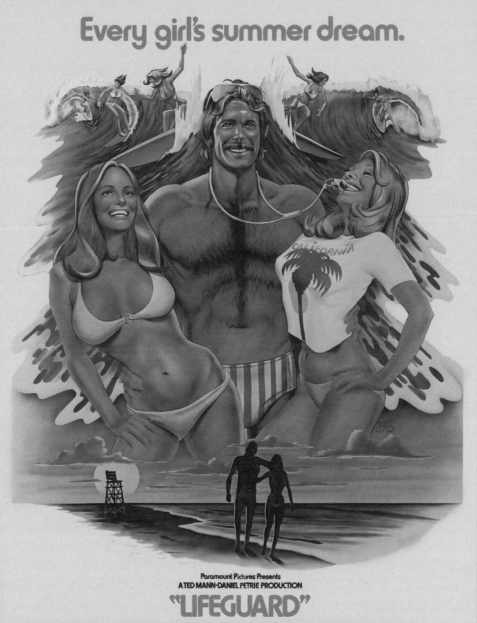

Every girl's summer dream.

Paramount Pictures Presents

A TED MANN-DANIEL PETRIE PRODUCTION

"LIFEGUARD"

SAM ELLIOTT · ANNE ARCHER · STEPHEN YOUNG · PARKER STEVENSON and KATHLEEN QUINLAN as Wendy

Executive Producer TED MANN Written by RON KOSLOW Produced by RON SILVERMAN

Directed by DANIEL PETRIE 'Time and Tide' Words and Music by PAUL WILLIAMS

PG PARENTAL GUIDANCE SUGGESTED Music Scored by DALE MENTEN In Color A Paramount Picture

76/121

"LIFEGUARD"

113

a dirty town that had summoned me like a beatnik to a house of jazz.

From the moment I saw *Psych Out* (1968), the prophecy was in. My job was to be incarcerated in a warehouse on 3rd Street in San Francisco, running a drunken spaceship, and paying the bill on a speaker wire to nowhere. We were the "sanctuary" where runners hunkered in the wee hours, douching putrid postSmack forces. Much of my time was spent as an exorcist. I came to realize the city was the property of Satan and Company. If I stay, I thought, I will get sick or go to jail. The end of a twelve-year "season" was on us like a kerosene suit. I've heard it said "Americans come from nowhere. If they weren't born there, they learn to replicate it." Or, to quote Baudelaire, "No one says goodbye to rubbish ready for eternity." *That* was the Werepad: trash *en garde*, or SuperTrash for eternity.

The argot of Mondo-narrators, the wisdom of hucksters, the brief brilliance of dialogue--when exquisite, these expressions protest that cinema is word specific. In Matt Cimber's *He and She*

(1970), an instructor's voice tempts the purchase of "an inexpensive red bulb" for the home boudoir [advice followed by Alvy Singer in *Annie Hall* (1977)], and the syntax regarding blowjobs is absurdly genteel: "The female must bear in mind that the male will also enjoy the oral stimulation of his genitals," as is the clause, "not at all unpleasant," to describe semen flavor. Then, in an example of philosophical marketing, William Castle testifies, "A SCREAM AT THE RIGHT TIME MAY SAVE YOUR LIFE!"

Here are four items of compact dialogue, small lasers of words igniting phonemic fetish: "This silly pistol can make a hole in you the size of a medium grapefruit" [Vincent Price in *The Tingler* (1959)]; "Strange girl, don't be so uptight" [Bradford Dillman in *Black Water Gold* (1970)]; "Punks, just punks!" [Jack Palance in *I Died a Thousand Times* (1955)]; "A sun that was like the great white bone of a giant beast that had caught on fire in the sky" [*Suddenly Last Summer* (1959), proof the movies have no fatwah against poetry].

Language from cinema utters unlike

[continued on page 140]

114

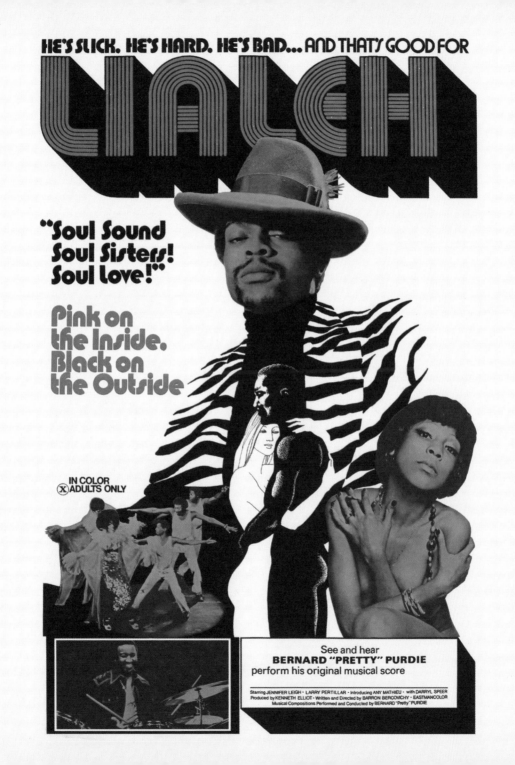

...AND
IN THE
END

RE-CREATED
MAN.

116

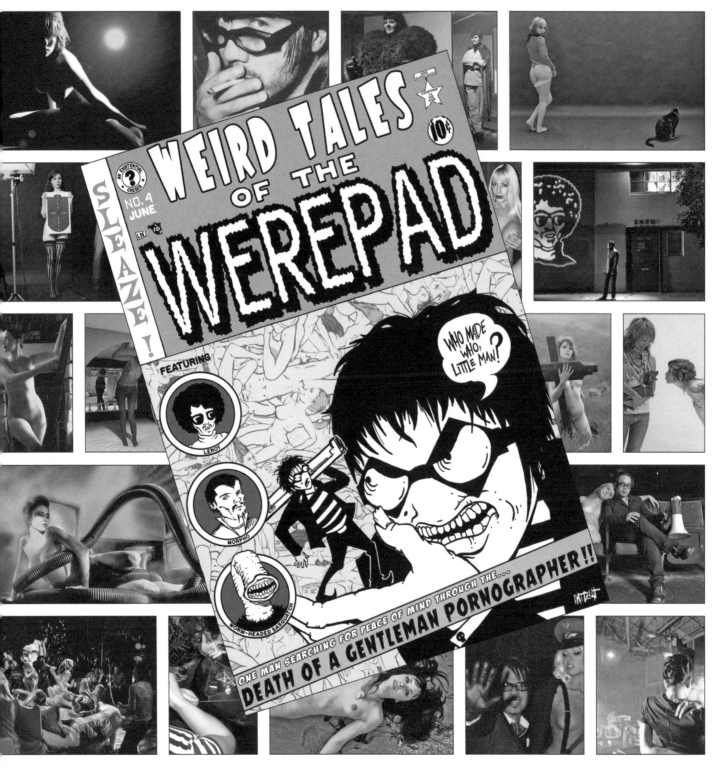

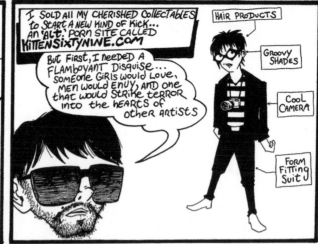

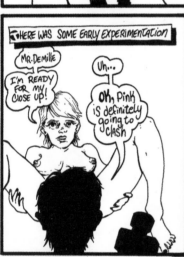

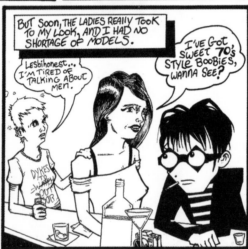

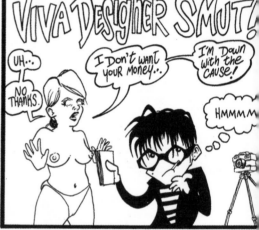

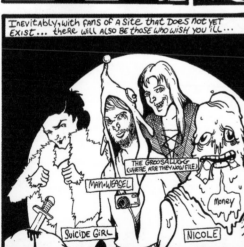

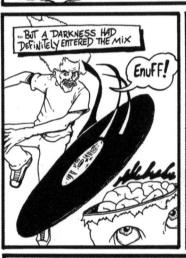

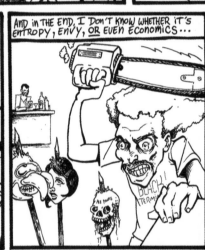

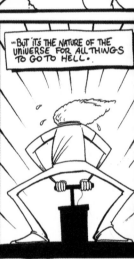

HELL HATH NO FURY..

NO MAN IS SAFE FROM THE "PREACHERWOMAN"

EVIL COME EVIL GO

She's a Man-Hating, Hymn-Humming Hell Cat!

IN COLOR

A
MANUEL S. CONDE
RELEASE
HOLLYWOOD, CALIF. U.S.A.

Written & Directed by WALT DAVIS Produced by ROBERT C. CHINN

125

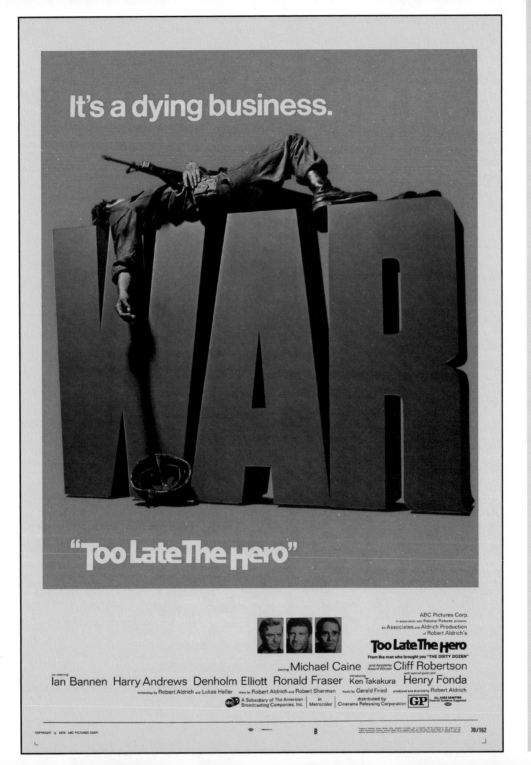

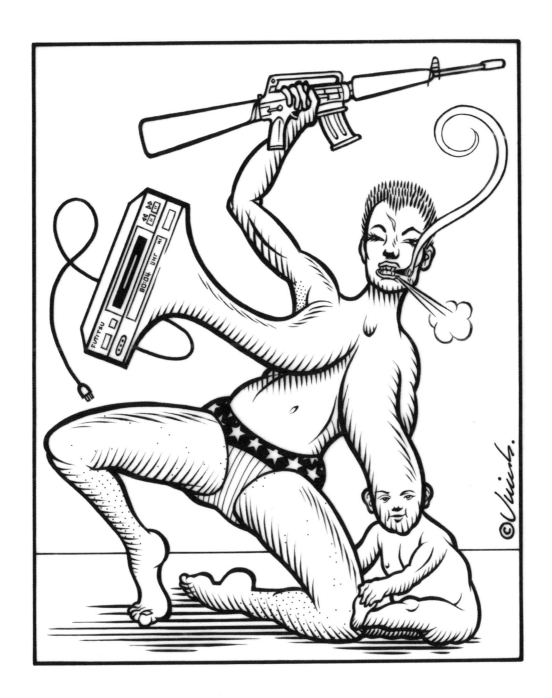

127

WARREN
MAGAZINE

FAMOUS
MONSTERS
#123
MAR. 1976

FAMOUS

MONSTERS

OF FILMLAND

PDC $1.25

58380-8

SPECIAL HOLIDAY ISSUE

Norman Lear, Jane Fonda,
MTM, Superman, Big Bird
et al. salute Old Glory

Match wits with the
U.S. crossword champ

On *Golden Pond*'s golden boy

MARCH 22, 1982 ■$1.00

People weekly

John Belushi

A dangerous life,
a tragic death

WARREN MAGAZINE

MAY 1979
$1.75
58885-6

VAMPIRELLA

#78

KISS OF THE DRAGON QUEEN!

E FIGHTING
RST LADY
HORDS-AND-
ORCERY!

LIFE

June 1979/$1.50

Long-Awaited Movie
About Vietnam

Scariest
Roller Coaster Rides

Those Unforgettable
High School Years

Marlon
Brando
in
'Apocalypse
Now'

136

CINEFANTASTIQUE

January 1986

Volume 15 Number 5

$4.95

CAN $6.70

UK£3.35

137

any other--like therapy for ghosts!--and speaks to our "wounded bewilderment," which is the very "de-center" of emotion, the sponge nothing can exit from, where exhibistentialism forces passivity and aggression to anoetic covenant--i.e. a state of consciousness in which there is sensation but no thought. I imply a stereophonic trap--the aural part of voyeurism--into which we disappear like the Incredible Shrinking Man. Thus do we experience the hypallage of "flow with the go," until the conjuror is conjured again.

Quantum means all things exist. Out of the quaquaversal sensing of Many, the brain 'chooses' to either see or remember. It seems fair inferring that to do this is a defiance of everyday multiplicities. As to what a blend of seeing and remembering might produce, you could say: We see as we see while we see, and eventually if we keep seeing something it must be because we keep remembering it too. Remembering spreads through the core of daily seeing. If you're really into movies, you could conclude seeing is remembering to look.

For me, these thoughts skulk back to:

"Reality is what you've got to see in order to make your vision a (fetish) of reality." Fetish is a quantal weaving of non-denominational appreciation. A notorious worship is recommended. Partial moments, incomplete scenes, expired ideas, splintered frames, untraceable hearsay: all are go-to grist for fetish, which at its polymorphous base, desires revisionism ad nauseam.

Therefore, *Elvis on Tour* (1972) becomes a horror movie, each song a Grand Guignol slaying. In *The Onion Field* (1979), we inhale a "bleeding third eye" when the nude black inmate hacks a wrist (his) and lifts the cut to his pate. In *The Public Enemy* (1931), James Cagney's shockingly laughable post-mortem pratfall as the Frankenstein-swaddled thug removes any thought of barrier between gangster and monster movies. And in Europe, Bronson was anointed The Holy Monster. The word "monster," at root, means exhibit, reveal; simply, to *show* (connoting ceremony befitting the dawn of a sign--i.e. recognition that Bronson was monstrous, male, ugly, beautiful, holy). One could even make fetish of the 2004 *Wired* magazine article that data-analyzed how there

was more purchase power in the bottom 50,000 (or so) than the top 40. This got hailed as the discovery of "the long tail." The marketplace is a beast of fetish, the donkey, all tail.

The alleged incompatibility of "highbrow" and "lowbrow" culture is aesthetic apartheid, yet the most undesired inference one could make about SuperTrash is that art and trash are somehow interchangeable, when rather, they are inseparable, instructing each other through an obsessive duel. In the words of Montaigne, "There is a greater difference between one man and another than between two animals of different species." Except: our "little worlds" don't matter by themselves. The possibility of paranoid conflict with another permits meaning.

SuperTrash is an encounter of irreconcilable unity where art and trash coevolve and become like one and consolidate human identity. For Mallarmé--in what is evidence of how poets pre-form the work of scientists--the element of (futile) chance and the externality of the (abyssal) real are expressed by the word, "outspread,"

or *éployé*, while the unifying act of the poet is "to fold," or *reployer*. This approach amazingly anticipates Robert Anton Wilson's concluding arguments in *Quantum Psychology* (1990) regarding Dr. David Bohm's correlation theories of a local explicate order and a non-local implicate order.

It is thus a matter of redacting multiplicity until the quanta interpenetrate and simulate totality. By defeating our thoroughly compromised cognizance, defined as "knowledge obtained by observation or information," we matriculate to SuperTrash.

SuperTrash is a retreating progress to a haven more disciplined than constructs defering to genres, schools, or history. By returning philosophy to the barbed vapors, the occult guts and hermaphro Vortex, opportunities for discovering the 21st century zit the grid.

New Wave Hooker ideology is not just a fashion thing. When coupled with its "yang" associate, bad gods, we begin to "yin" in the sense of regaining what is problematically femme. New wave hooker makes a trinity of the virgin/whore ratio

FREE OFFER
THAT YOU CAN'T REFUSE!

HAWAIIAN PUNKS

BLOODY NOSE RED

BEATS YOU TO A FRUIT JUICY PULP

by adding the "robot."

True to the cold preferences of yin, the soul is involved (but in the Joycean spirit of soul-as-smithy, a place of hard contact). Out of self-spectacle, The NWH forges worship for an inner, unseen shield that carries to market a fertile and resolute seed. We are talking about a metaphor for not only child production, but also the adaptive skills and robotic proclivities that weaponize the feminine.

By aligning maternal hydroplaning with dangerous fashion, the new wave hooker escapes from at least two conditions: 1) the ignorance, innocence, and inexperience of the virgin; 2) the reality and dead-end of the whore. What is manifest here is not destiny, but well-aimed mystery, that is, an "other-goddess"--the displaced forward of the feminine-- pinching the means to control procreation, humanity, you, me.

At its most effective, Nature is an act of will. Nietzsche anticipated NWH: "What inspires respect for woman, and often enough even fear, is her *nature*, which is more 'natural' than man's, the genuine, cunning suppleness of a beast of prey, the tiger's claw under the glove, the naivete of her egoism, her uneducability [i.e. the lasting resolve of her nature] and inner wildness, the incomprehensibility, scope, and movement of her desires and virtue."

I get from this a romantic premonition of postfeminist, gender-confused "she-will," a sort of putsch without direction.

The NWH torpedoes the starter proposition, "What you see is what you get," and also dooms (from a future site) the boast, "You ain't seen nuthin' yet."

In other words, new wave hookers offer no reality, make no promises, but get all the attention!

A NWH corollary would be invisible slut Heidi Abromowitz, whom Joan Rivers built her career apoplectically worshipping/ reviling. The big outing of NWH style occurs in Bob Fosse's *Cabaret* (1972), which outdoes flowery "It" girls by applying goth warpaint and sexy fascism.

This "statement" congratulates athletic, aggressive neo-maternal drugginess--i.e. glam. (As Liza Minnelli said of Alice Cooper and David Bowie: "They took my look!")

NWH goes on to trend in the coked-out, airbrushed (if not spray-painted, galvanized) models populating mid-to-late 1970s *Playboys* and *Penthouses*, in which

gloss incarnate, startled viciousness, and bush power--cause Eros and Thanatos to convene in a melt-up.

The new wave hooker shows up in pop smashes like Broadway's *A Chorus Line* (1975), or Farrah Fawcett's great blond shark poster (1976), and the NWH signs of prowess-and-style exude from superjocks Dorothy Hamill and Nadia Comaneci. These 1970s bionic women talk back to the cyborg fatale of Fritz Lang's *Metropolis* (1927), as well as the terminator chicks that dick Film Noir.

New wave hooker ideology tangs the '80s: *Foxes* (1980), Giorgio Moroder's *Metropolis* (1984), *Crimes of Passion* (1984), *Cat People* (1982), *Blue Steel* (1989), *Flashdance* (1983), *Liquid Sky* (1982), *Xanadu* (1980), *Vice Squad* (1982), *Streets of Fire* (1984), *Youngblood* (1986)--forever hustling with break-fu body language, in the exterminating neon, scheming their sublimations of pornography.

Hermaphro chic like Genet's prison opens too many doors. Robert Redford becomes the original Farrah Fawcett. Instead of singling *Octopussy* (1983) as the "ultratoe" of cameltoe movies, we cite "camel-bro" in *Megaforce* (1982), *Labyrinth* (1986), and Black Oak Arkansas's Jim Dandy.

The logic of hermaphro makes homo normal and hetero deviant. The upshot: you notice more when you go hermaphro--e.g., The Fat Albert crew's nymphy catamitey repose at an inner city swimming pool; Clint Eastwood's wickedly gay small talk with toothy Burton Gilliam in what could be the most hermaphro buddy movie, *Thunderbolt and Lightfoot* (1974). James Remar's close-ups in *The Warriors* (1979) are total thus spake chic. In *Exorcist 2: The Heretic* (1977), cross-vibes between Pazuzu and Linda Blair compound an environment of hermaphro insectile ecstasy. Strother Martin, [*The Man Who Shot Liberty Valance* (1962), *Cool Hand Luke* (1967), and *The Wild Bunch* (1969)], pierces as a fundamentally "tonal" hermaphro, his voice sows bitchiness (certainly a cut is

felt in the "What we have here is a failure to communicate" scene in *Cool Hand Luke*).

The remarkably consistent femme fatale in film noir is iconic hermaphro, but fatale riffs appear all over: hardened, post-Lolita Sue Lyon, *Murder in a Blue World* (1973); Richard Crenna's wife-in-pajamas-on-morphine, *Doctor's Wives* (1971); the militantly hot Andrews Sisters killing it in *Buck Privates* (1941); "possessed" Sigourney Weaver, *Ghostbusters* (1984), a new wave hooker if ever.

Hermaphro chic sends black culture on a mission to associate zaniness with liberating fuck-yous. I can't get over the black midget in the bubble bath in *Rockula* (1990), or Fred "black girls are mean" Williamson's seductively effeminate King Cobra ads ("Don't Let The Smooth Taste Fool You"). Ving Rhames' rendering of Don King for HBO macks a vodun as macho-goofball as Carl Douglas's hit tune, "Kung Fu Fighting" (1974). To be silly and serious is boilerplate camp. But, demonstrated no better than by disco-hermaphro Sylvester: to be black, silly, and serious is a farther shore. Louis Gossett Jr. vamps the whole great white

shark franchise with one line in *Jaws 3* (1983): "You talkin' about some damn shark's mother?"

In essence, the black/white game is profound like yin/yang--it supports the notion of struggle as admissible, cruel, and funny. On *Sanford and Son's* first episode (1972), Redd Foxx cracks, "Ain't nothing on Earth uglier than a 90-year-old white woman." To make chic chic, you need a woman to cap it. In *Carmen Jones* (1954), Dorothy Dandridge's control over Harry Belafonte is brutally hermaphro. Concerning the matter of her toes: "Blow on 'em," she orders.

We're all a shade of feline, but it's dog-eat-dog, even for the cat (ergo the affinities among bad gods and new wave hookers). Throw in hermaphro chic and next thing, the lady isn't just a tramp, she's a dick. And dude is on his period.

On reflex when visualizing new wave hookers, we see glossy girls atilt in neon night. Tableaux of prostitutes bring ancient and future shocks together. The collaboration between vulgar spectacle and personal turmoil creates a burden of association that, literally, works out--80's aerobics videos can be claimed as

"It's Chicken lickin' good"

COLONEL CHICKEN'S RECIPE
Kentucky Fried Fingers
BETTER THAN BITING YOUR NAILS

144

[continued on page 146]

a radiant expression of the new wave hooker, arguing for a healthy body to admit it needs a mechanized identity, one that can prevail over the vulgar or the personal (as Sartre described female ass: "that blind and public mass which belongs to everyone before belonging to them").

Going back to dialogue from *Metropolis*, "The robot is almost perfect. All it is missing is a soul." "You're mistaken. It is better without one." This sentiment is nurtured in a fascinating act of reductionism by a creature named Tamilee in her workout tape. She announces, "Metabolism burns fat."

The bad god is more difficult to theorize than the new wave hooker. The unexotic explanation is I am too emotionally involved with the bad god. I like him a lot. He is the ridiculous and messianic soul of men and sometimes he is a woman. But always, a force of one, filled with transparent karma, the bad god operates with absurd near-total awareness. His path leads the future to some immutableness. Cinematically, though he may be on a team, the bad god is anti-buddy, but pro-body, meaning that, like the new wave hooker, mind is maximum body.

BG can be a fool king like Jerry Lewis in *Hollywood or Bust* (1956) with a geyser of faux cum rising from his cowboy hat. He can be Robert Mitchum in *Secret Ceremony* (1968), dashing weird vibes to Elizabeth Taylor with a pervy, cynical, understated viciousness. Or he can be Liz as she is Harris Glenn Milstead/Divine's inspiration in *Boom* (1968) or crudely horny in *Who's Afraid of Virginia Woolf* (1966). While Taylor's bad god style is showy and needy, Sharon Tate in *Eye of the Devil* (1966) perfs a bad god like some perfect blond jock: virile, vapid, evilly authoritative. When bad god is female, evil stacks with impunity. Male bad gods always manage a sign of regret. As Jim Murray interpreted from Thoreau, "Man should realize, from the depths of his own secret, that whatever he may hope to gain cannot be gained; for that which the individual wants to know about another individual is precisely that which he hides about himself."

This magnificent problem is discernable when Rutger Hauer mugs in the elevator after slaughtering Tyrell in *Blade Runner* (1982). A rapey, ski-masked gremlin dude in *Gremlins 2* (1990) tells the same story

of hilarious self-hiddenness. The bad god is turned inside out by virtue of being an impostor-on-exhibit, like Nazi-camouflaged Gregory Peck in *Guns of Navarone* (1961), volubly attacking his own affliction to be the leader of his wolf pack. The bad god is a philosopher. Says Tony Curtis in *The Vikings* (1958), "Love and hate are two horns on the same goat." The bad god is an unforgettably succinct character like Mr. Richie in *Sorcerer* (1977): "He robbed my church. He shot my brother. I don't care where he is or what it costs. I want his ass."

William Devane's Major Charles Rane in *Rolling Thunder* (1977) is perhaps the ultra toil-pampered BG. When his family asks why he stood for the mutilation of his hand, his punishers exult, ""I'll tell you why. Because he's one macho motherfucker."

In his sadism-sensitive study, *Obedience To Authority* (1974), Stanley Milgram states, "Orders originating outside of authority lose all force." The bad god is the door to discipline, and only a deeply ripped-up and taped-back together bad god can preserve authority.

As Lee Atwater figured out, "Winning is easy when you play hard and break all the rules." That's why I want to see a power trio of Freddy Krueger bass/vocals, Michael Myers keyboards/guitar, Jason Voorhees drums.

There is equipollence between art and trash, they are equally powerful, sharing a cardiac tide between diastole and systole: "Is it art or trash?" we ask forever like Sisyphus, whom Camus advises to imagine as being happy (and the same goes for Jesus--imagine Jesus as despair's happy chaser and you are SuperTrash). Continuing with the heart metaphor, in the rest beat of the diastasis--which is the saddle of equipollence--there is rumble, to quote Nietzsche, "a storm pregnant with new lightnings." Art and trash share custody of the controlled chaos from the 20th century: avant-gardes such as Surrealism, Dada, German Expressionism, Fascism, Neo-Realism, Film Noir, The Beat Generation, Jazz, Abstract Expressionism, Pop Art, The French New Wave, Psychedelia, Hardcore Pornography, Grindhouse, and Punk Rock.

All these above movements use high

[continued on page 149]

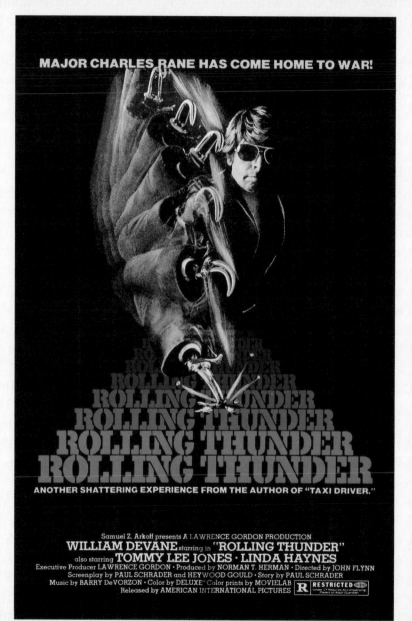

MAJOR CHARLES RANE HAS COME HOME TO WAR!

ROLLING THUNDER

ANOTHER SHATTERING EXPERIENCE FROM THE AUTHOR OF "TAXI DRIVER."

Samuel Z. Arkoff presents A LAWRENCE GORDON PRODUCTION
WILLIAM DEVANE starring in "ROLLING THUNDER"
also starring TOMMY LEE JONES · LINDA HAYNES
Executive Producer LAWRENCE GORDON · Produced by NORMAN T. HERMAN · Directed by JOHN FLYNN
Screenplay by PAUL SCHRADER and HEYWOOD GOULD · Story by PAUL SCHRADER
Music by BARRY DeVORZON · Color by DELUXE® Color prints by MOVIELAB
Released by AMERICAN INTERNATIONAL PICTURES

R RESTRICTED
Under 17 Requires Accompanying
Parent or Adult Guardian

and low coordinates to bind the sacristy of art with the demotic of trash. Their style is aggressive, sexual, rebellious, quixotic--generally they work to attach the philistine and the connoisseur within the same person.

What these eras share is: they have become intellectual properties of postmodernism. "Slaves of content."

They are part of a content surplus--with "content" being the unassuring merger of experience, commodity, information, technology--which foists on us a unique censorship.

Not a situation of biased censorship, this censorship is the belly of a snake full of rat and the snake cannot eat more. This censorship is a predicament of an indigestible volume of content-- a.k.a. "all the great stuff from the 20th century."

One could say too much was produced in the 20th century, and that postmodernism was the efficient way to acknowledge it. But now we are teased by truant meanings and stimulated by a hallucinatory ratio of "too much and too little," and none of the avant-gardes can push on. They have become *arriere-gardes*, enormous concrete shoes, a dream burden.

The Greek *katalepsis*--i.e. "a grasping"-- speaks to the difference between touching versus holding. Information is touchable but knowledge is to be held. The curse of postmodernism is that information mimics knowledge. Since information is easier to use, knowledge meets neglect. While the ingredients of a 21st century are evident, abundant, there is grasplessness.

These newly cast *arriere-gardes* must stoke the Id of the 21st century. Restoring an Id is the notion of consciously-striving-to-be-subconscious. The dramaturgy of SuperTrash is to grubstake a bionic Id Trek.

In the words of Dali, "The cyclotron of Dali's philosophical jaws was craving to pulverise and bombard everything with the artillery of his intra-atomic neutrons, in order to transform to pure mystic energy the vile visceral and ammoniacal conglomeration of biology to which the surrealist dream gave access. Once this putrefying profusion had been

[continued on page 154]

Dirigida por: ROMAN POLANSKI

¡SEXO! ¡VIOLENCIA! ¡SADISMO!

REPULSION

BESTIALES INSTINTOS... DESEO Y LOCURA... DEPRAVACION Y CRIMEN!

Estrellas

CATHERINE DENEUVE

(BELLA DE DIA)

IAN HENDRY
JOHN FRASER
PATRICK WYMARK
YVONNE FURNEAUX

Dirigida por: ROMAN POLANSKI

¡SEXO! ¡VIOLENCIA! ¡SADISMO!

REPULSION

151

n size, new all around.

The new Kodak
Ektra cameras.

Introducing the new,
easy-to-use pocket
cameras from Kodak:
the Kodak Ektra
200 camera and
Kodak Tele-Ektra
300 camera. Both
take clear, sharp
pictures. One has
both normal and
tele lenses. And
prices start at less
than $25! That's
really easy to take.

 1880 Kodak 1980

America's Storyteller

completely and definitively spiritualised, man's mission and purpose on earth would be fulfilled, and all would be treasure."

SuperTrash is an energy that teaches not to look again, but, rather, to abandon believing in fully looking. To proceed we must let go of voluntary memory. For those who know Proust and particularly Beckett's interpretation, the prospect that our finest moments are self-undoings is acceptable. Not the epiphanies of Joyce (though they are crystalline, they attract dust), not the eurekas of science, nor the blessings of interesting taste, and certainly no type of success can compare with seizures of involuntary memory breaking the soul into many nowheres for the heart to find.

She is Candy. I am She=me. In this room I remember her in the sphere. We decided we were strangely overdeveloped. Before I could take it in...murmurs..."Get in the mood Candy Von Dewd."
Which meant SAVE THE EARTH.
That was ways off. Meanwhile I was frozen, but hot, too. My mentations bubbled. I moved in slow mo. I felt my own limbs. I had no place to go. I listened for a

long time.

"Hello Candy."
Yes.
"Can you hear?"
The voice grinded as a part of my face started to open. I wasn't prepared for my soft edgy mouth or the surf of halation that terrorized my eyes. I drifted to a distant bombardment. I clung to gas and tacked until a fluttering grid came around me like a capsule. Here I formed pink nails, vanilla hair, white skin.
Next chapter...
CANDY GETS A RAYGUN

The unity of Art and Trash, based on irreconcilableness, is a home-run dialectic. You can trust that, if art and trash are co-at it, there is game. For the sake of deconstruction let us wonder whether:
Art is really Trash.
Or
Trash is really Art.

The first proposition, "Art is really Trash" channels to "art is really art," in the sense of understanding Trash as the "means by which" Art re-knows itself. The key action is: disgrace Art by affirming

Trash, and see how disgrace affirmatively stigmatizes Art. By itself affirmation is misguided, futile; but affirmation can guide the value of disgrace (the economic corollary is to be "successfully poor").

The second proposition, "Trash is really Art," revolves into "trash is really trash." In this case we "achieve" Trash by redescribing Art.

Art disgraced is cooler than Trash achieved, and I suspect also more serviceable. That's because Art is in the business of separating the thing and the idea, whereas with Trash, the thing and its idea are fused. Think of Art as the moment when a thing and an idea are able to separate.

Think of Trash as the death of that moment (Trash as fossil fuel, the reign of putrefaction, eons of churn providing a fomenting base for Art).

At the Werepad, we often screened movies two-at-a-time, side-by-side (or in the case of anamorphic prints: top-and-under). We called these meticulous projections, Simulvisions. We did obvious pairings like *Bullitt* (1968) and *The Driver* (1978), or druggy doubles like *The Trip* (1967) next to *The Terror of Tiny Town* (1938). We lined up the pilot episode of *The Six Million Dollar Man* (1973) with *Straw Dogs* (1971), and during the O.J. Simpson Festival we matched *The Cassandra Crossing* (1976) with *The Towering Inferno* (1974).

The Werepad position was, cinema in the '90s was being fucked over by: Sundance rhetoric and shittily designed movie posters and viperous grant committees and heinous corporate theaters or boringly quaint ones and the sacking of cool by irony and the L.A. hegemony everyone wanted a piece of and the voices that did not tell Coppola and Lucas, hey you're just part of something bigger than your biggest.

In San Francisco it was depressing to constantly meet computer guys unversed in the beauty of Lee Marvin. Billeted in the megalith of the Werepad, I felt like Tolstoy's "unconscious life within the swarm." I was just glad I had a subconscious to tell me cinema is basic psycho and dark fire and pretty kitty and chocolate thunder and dead elf.

[continued on page 158]

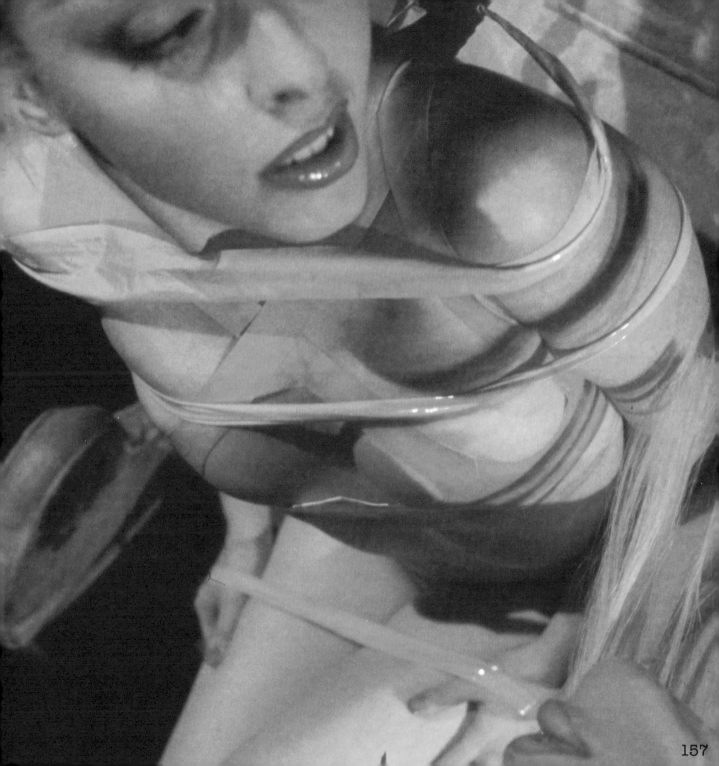

Me-and-my-arrow became me-and-my-black-widow. I perished in high-maintenance loveless relationships. I decided grindhouse wants cunty intellectuals because nothing is weaker than accolades (or aspersions) from evil nerds. SuperTrash is a "discipline" traced from a lot of looking at the world like a comic book. I'm sold on shifting values and unpredictable scores, yet per the adage, "Show me a great movie, I'll show you a restraining order," ascesis prevails as the means for elegantly transmitting excess (which is how Pink Floyd created scale). Fetish and magic depend on tight self-curation, if one is bent on living a poetry of

consumption. I wanted to call this book *A Nigga Talkin' Shit Is Serious Business*.

Any fan of chic relishes Antonioni's *Blow Up* (1966), without which, Warhol's Pop wagon would have had less wheel. It's interesting to dun back the scene's hoopla and return to something as "banal" as the exhibitor's manual/press kit for *Blow Up* which pedals stuff like "Antonioni's camera never flinches. At love without meaning. At murder without guilt. At the dazzle and the madness of London today."

Pithily, these tags establish a playbook for "involuntary memory"--à la Beckett's analysis of Proust--where voyeuristic control is abruptly cratered by subconscious assemblies. The spiel of the kit attaches love and murder to each other after they've been purged of baggage like "meaning" and "guilt." Only then do they associate freely; and certainly there is a message in the ad text that good times and mental illness are partners.

Chic is never far from hell. I suppose the hell it enables is the possibility of a personal one with artistic benefits and key omissions. Chic is what fatigues a phantasm, telling lies to build scenes. To propose, "psychotic" art that wins praise tends to make people struggle with the mysteries of their admiration and press on to weaker meanings. *Goodfellas* (1990) is a great example. According to the filmmakers, the violence is inglorious and repellent and yet helpful because it shows what gangsters will get for being gangsters. This is deceitful. The carnage in *Goodfellas* is, one, structural: a necessary grammar upon which the timing of the

[continued on page 161]

NOTHING WILL PREPARE YOU FOR

THE HAND

An EDWARD R. PRESSMAN-IXTLAN Production
MICHAEL CAINE
"THE HAND"
ANDREA MARCOVICCI
Director of Photography KING BAGGOT Editor RICHARD MARKS
Music Composed by JAMES HORNER Produced by EDWARD R. PRESSMAN
Screenplay by OLIVER STONE Based upon the novel "The Lizard's Tail" by MARC BRANDEL
Directed by OLIVER STONE Technicolor® Panavision®

159

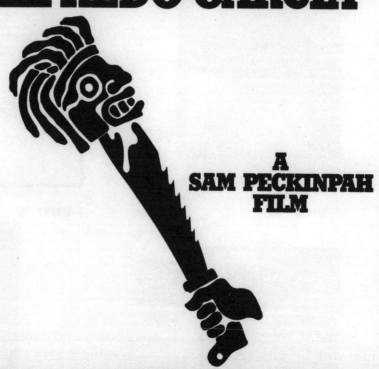

product totally relies, and two, psychotic: a loop of blood pornography: "money shots" ranging from abrupt, manicured spurts to musically enhanced, necrophilic arousals, to straight-ahead knife rapes.

Poetry is for accuracy, joinery, and irrational relief. Pascal proved with his

pyramids of poetry and green memory... My huckleberry can signal through the flames and Leroy the Fro-Magnon is trucking the louche lathe of despair and his muppety moan has you when you're together at the Werepad, wonders cluster in the 4-speed lovebox, vinyl dungeon, and beatnik scene suspension. You and Fro-Magnon appreciate the stoic beauty of a clean cave, and *fin de siècle* by candlelight--caught in the evolution that sets you apart like a hard smooth bright spider-web light. There is falling seed and insightful devastation. Buddha said "Evil does not exist." Neither does the front of the bus. The bus is all "back."

barometer in Clermont Ferrand that atmosphere had weight; I spent twelve years cooped in the environment of the Werepad attempting to prove trash is super.

At the time, we had a way of marketing it: Come dig Werepad's Simulvision-propelled ambience and go bananas amid

Thus SuperTrash, the future emetic aesthetic relic. Piercing boisterously, stropping perception. The persisting mist. The bitch in the lake.

Then on the anomaly that an "institution" did not fear my shit, I really spit. I did this at Yerba Buena around 2007, with a SuperTrash signshow.

[continued on page 177]

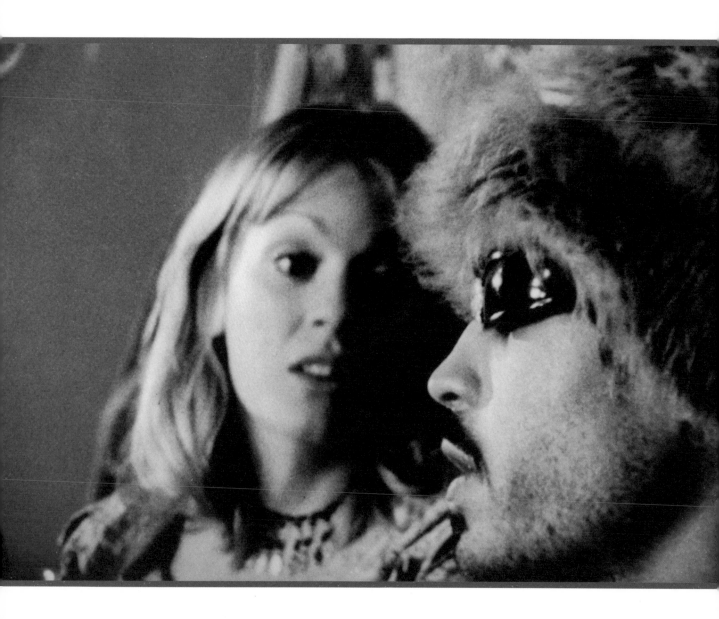

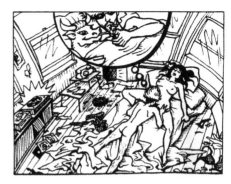
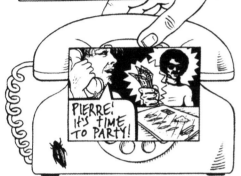
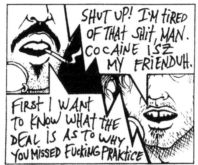
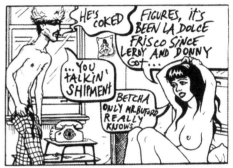

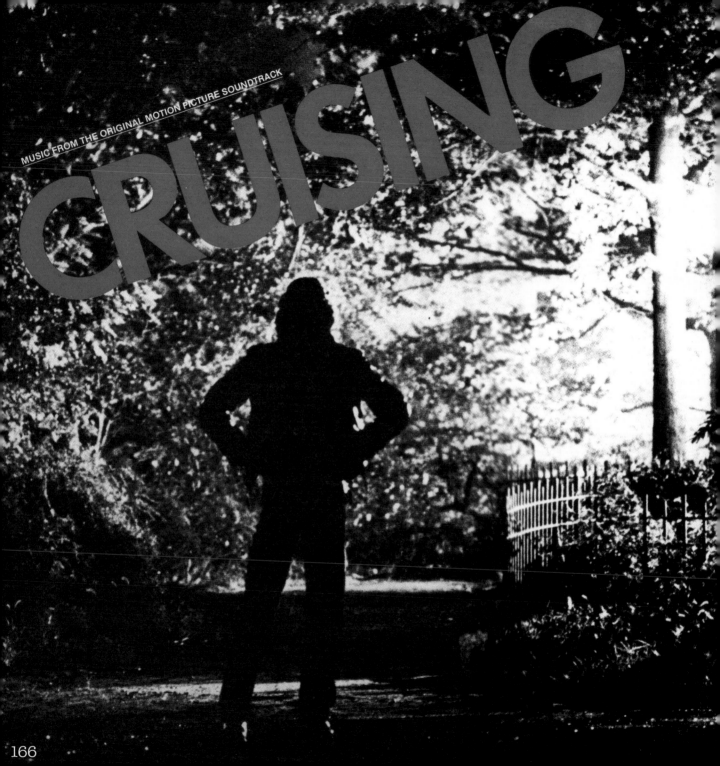

MUSIC FROM THE ORIGINAL MOTION PICTURE SOUNDTRACK

CRUISING

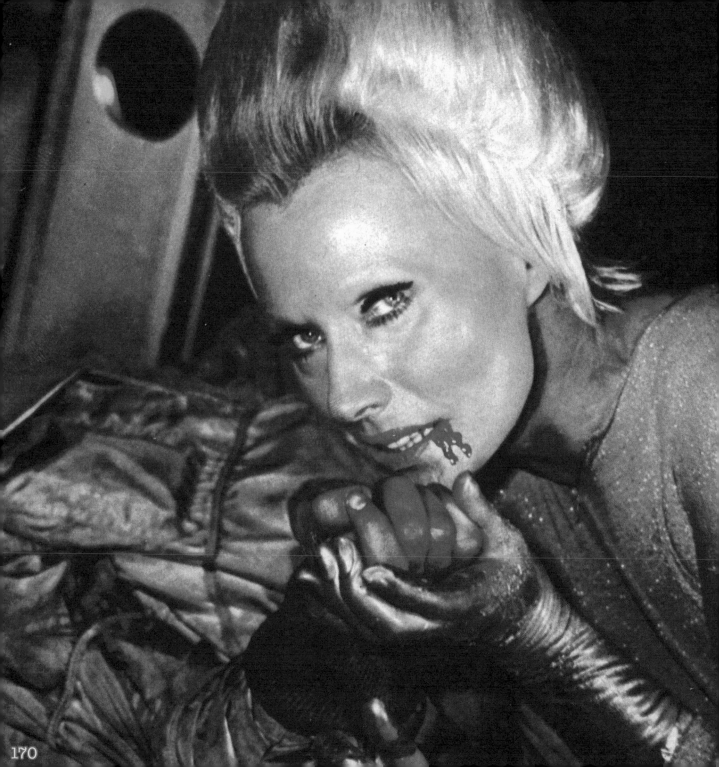

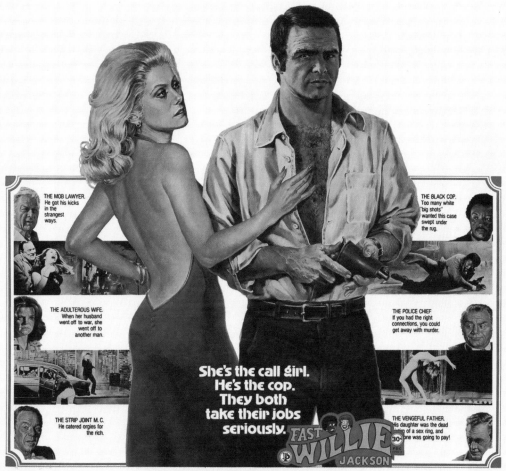

They're hot.

THE MOB LAWYER.
He got his kicks
in the
strangest
ways.

THE BLACK COP.
Too many white
"big shots"
wanted this case
swept under
the rug.

THE ADULTEROUS WIFE.
When her husband
went off to war, she
went off to
another man.

THE POLICE CHIEF
If you had the right
connections, you could
get away with murder.

She's the call girl.
He's the cop.
They both
take their jobs
seriously.

FAST WILLIE JACKSON

THE STRIP JOINT M.C.
He catered orgies for
the rich.

THE VENGEFUL FATHER.
His daughter was the dead
victim of a sex ring, and
one was going to pay!

Paramount Pictures Presents

BURT REYNOLDS
CATHERINE DENEUVE
in
"HUSTLE"

Also Starring BEN JOHNSON PAUL WINFIELD
EILEEN BRENNAN EDDIE ALBERT as Leo Sellers and ERNEST BORGNINE
Co-Starring JACK CARTER Written by STEVE SHAGAN Produced and Directed by ROBERT ALDRICH Music Scored by FRANK DeVOL

"A RoBurt Production" In Color Production Services Furnished by CHURCHILL SERVICE COMPANY A Paramount Picture

In the heart of every victim is a hero and he'll tear apart a city to prove it.

PURSUED

ARNOLD KOPELSON Presents A JAY WESTON Production

JAMES BROLIN CLIFF GORMAN RICHARD CASTELLANO

Director of Photography	Music	Based on the Novel by	Screenplay by
VICTOR J. KEMPER A.S.C.	ARTIE KANE	WILLIAM P. McGIVERN	BILL NORTON SR. & RICK NATKIN
	Executive Producer	Produced by	Directed by
	ARNOLD KOPELSON	JAY WESTON	ROBERT BUTLER

"NIGHT OF THE JUGGLER" 800025

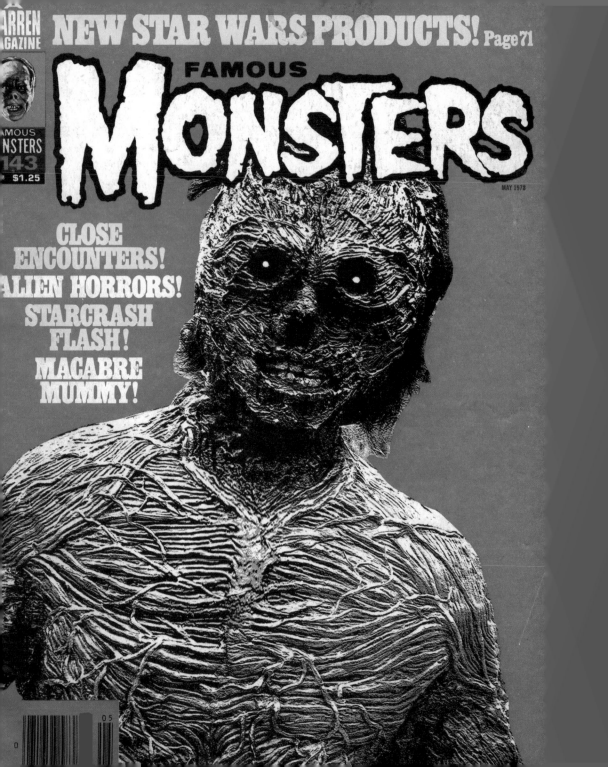

WARREN MAGAZINE

FAMOUS MONSTERS
143
$1.25

NEW STAR WARS PRODUCTS! Page 71

FAMOUS
MONSTERS

MAY 1978

CLOSE
ENCOUNTERS!
ALIEN HORRORS!
STARCRASH
FLASH!
MACABRE
MUMMY!

05

0

Rallying for pit bulls

Actress Linda Blair and Elvis, a 7-year-old pit bull, rally against SB 861 Monday at the Capitol. The legislation, proposed by Jackie Speier, D-San Mateo/San Francisco, would allow local goverments to institute breed-specific laws and regulate breeders.

Free-lance photographer David Hemmings prepares to shoot a magazine layout with five of his beautiful models.

A CARLO PONTI
PRODUCTION "BLOW UP" IN COLOR
A Premier Productions
Co., Inc., Release

7 Printed in U.S.A.

67/

I DRINK YOUR BLOOD I EAT YOUR SKIN!
Sparagmos--
Ritual dismember in day-glo.
Tacky too sugary sciomancy!
Content to END
so we can be
TRUTH for the DEAD

because it's not a straight shot to say that
THE
BEACH
GIRLS
AND
THE

MONSTER is art.
Call it SuperTrash
An expedition
Hidden schools like
Abstract Beatnikism
Punkscuro and other genre-less yet
precise pattern-recognizable
canons for academic Ewoks
and neo-grindhouse Luddites
to primitively pick apart
voila
movement from high to low and low to
high and lowest to lower and highest to
higher
is proof of culture
French cineastes, thru dervishness, an
ability to envy film noir as
a feat, enlist SuperTrash
You look at *Kiss Me Deadly* and *The Naked
Kiss*
Do you feel the equipollence
between art and trash
that has been so for some time now?
The win-win of SuperTrash is addictive in
as much as it is also true
America's Inevitable Africa
prophecized by Jack Kerouac, is!
Because for every *Ghetto Freaks* giggled
a *Blow Up* is given to the devil
Fashion, sabotage
Vice, beauty
Art, crime
Eat shit and blow me :)

It is consoling to get with Bela Lugosi as a way to approach the end. While it could be for suckers, I do love what he says in the pressbook for *The Raven* (1935): "It is my particular pride that even in the most fantastic of my film roles I do not use makeup. Instead of depending upon masks, casts, court plaster and false features, I create the illusion of a terrifying, distorted or uncanny makeup by an appeal to the imagination. An evil expression in the eyes, a sinister arch to the brows or a leer on my lips--all of which take long practice in muscular control-- are sufficient to hypnotize an audience into seeing what I want them to see and what I myself see in my mind's eye. In like manner, by the way in which I use my fingers and gesticulate with my hands, I give the illusion of their being misshapen, extra large, or extra small--or whatever the part requires. And I consider it part of an actor's art to be able to shorten or lengthen his body or change its very shape by the power of suggestion, without false paddings or other artificial aids."

Lugosi's tricks are in tow with the hermaphro chic/new

wave hooker/bad god writs of SuperTrash. He revels in the paradox of the hidden and obvious, understanding that, for the sake of expression, only the ineffable's contribution lasts.

I said at the beginning, "To what extent SuperTrash may be such a thing as a quantal, maya-packed oneness will depend on how enjoyable trauma in the form of thought-provoking-juxtapositions can be." If SuperTrash's funky take on cool shit has made you quit your job, then get to work! A yuppie witch from Ukraine had my chart read and the muddyduddy is my soul and personality are not cool with each other. So barring any hope for quaint kinky happiness, I have plotted this intervention into the relationship between art and trash because the greatest expressions are products of seething conflicts and apocalyptic fleetingness.

One of my favorite songs is the studio recording of Phil Ochs's "Pleasures of the Harbor." On a live album, he astonishes with the origin story: it was inspired by John Ford's movie *The Long Voyage Home* (1940) with John Wayne. My reaction:

[continued on page 180]

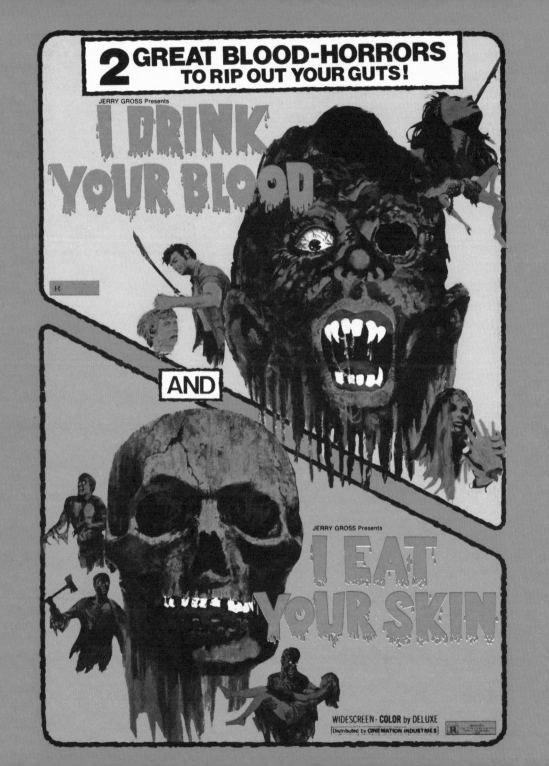

Bingo, motherfucker! *The Long Voyage Home* towers-in-the-abyss as Ford's most ghostly, pellucid portrait of the universe; emotionally de-centered on the verge of final discovery; of course it measures in Ochs' sirenic song about man writhing in eternity. What makes this a SuperTrash event is Ochs admits he had this passion for John Wayne, even though he was politically disgusted by him. Coincidentally it was Wayne (not just the creature from *Fellini Satyricon*) who excited the appliance of hermaphro.

For months I asked, didya know he was a hermaphrodite?

ONLY THESE TWO COULD TURN A FORTUNE
INTO A *MIS*FORTUNE

$TICKY FINGERS

A FRACTURED FABLE

SPECTRAFILM A HIGHTOP FILMS PRODUCTION "STICKY FINGERS"
HELEN SLATER MELANIE MAYRON
EILEEN BRENNAN LORETTA DEVINE
CHRISTOPHER GUEST CAROL KANE DANITRA VANCE
GARY THIELTGES GARY CHANG JESSICA SCOTT-JUSTICE
ROBERT REITANO SAM IRVIN JONATHAN OLSBERG CARL CLIFFORD
CATLIN ADAMS & MELANIE MAYRON CATLIN ADAMS

PG-13 PARENTS STRONGLY CAUTIONED

TITLE SONG PERFORMED BY COMPANY B · AVAILABLE ON ATLANTIC RECORDS AND CASSETTES

SPECTRAFILM
RELEASE

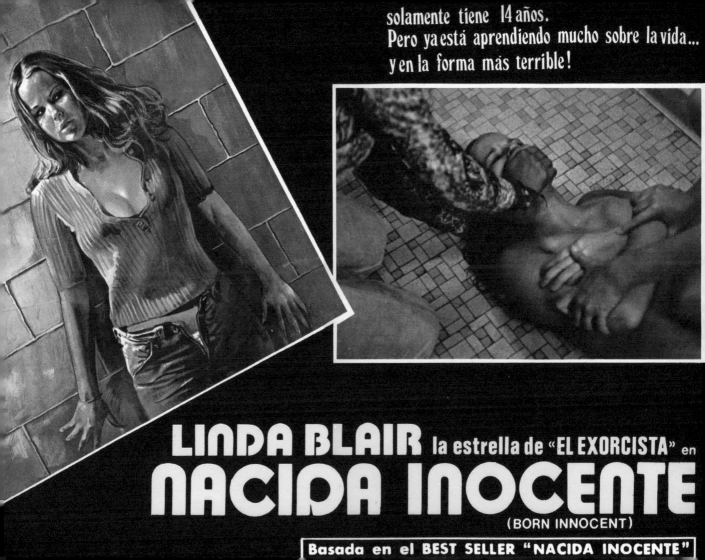

solamente tiene 14 años.
Pero ya está aprendiendo mucho sobre la vida...
y en la forma más terrible!

LINDA BLAIR la estrella de "EL EXORCISTA" en
NACIDA INOCENTE
(BORN INNOCENT)

Basada en el BEST SELLER "NACIDA INOCENTE"

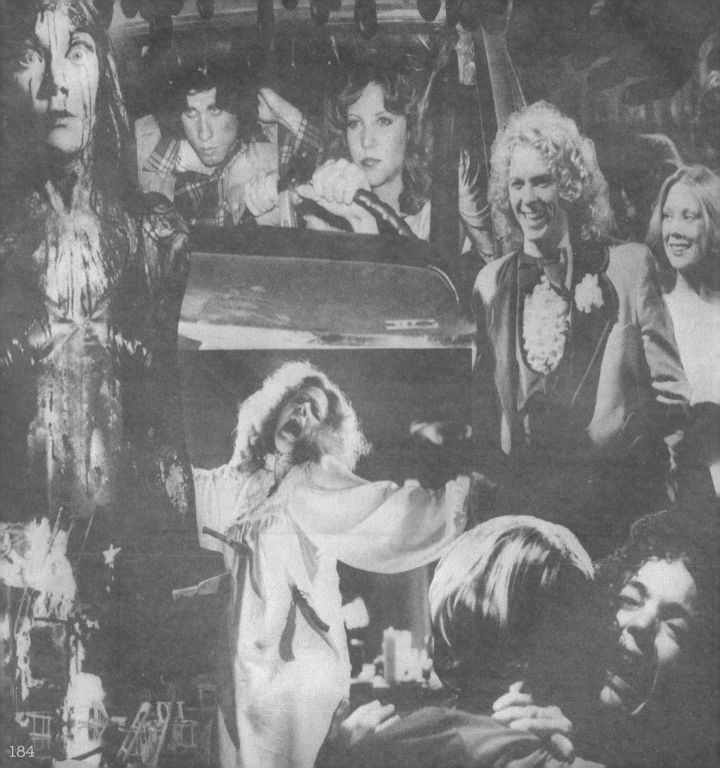

The Biggest Howl Ever Unleashed!

The scientists want to collar him... The crooks want to steal him. Digby — the biggest howl in the world.

DIGBY
THE BIGGEST DOG IN THE WORLD

CITY INVESTING FILMS presents A WALTER SHENSON FILMS PRODUCTION Starring
'DIGBY THE BIGGEST DOG IN THE WORLD' JIM DALE · ANGELA DOUGLAS · SPIKE MILLIGAN
Co-starring JOHN BLUTHAL · MILO O'SHEA · NORMAN ROSSINGTON · MICHAEL PERTWEE · CHARLES ISAACS book by TED KEY · Produced by WALTER SHENSON · Executive Producer IRWIN MARGULIES · Directed by JOSEPH McGRATH
Screenplay by Screen story by Based on the
TECHNICOLOR® FROM CINERAMA RELEASING

74/92

'DIGBY THE BIGGEST DOG IN THE WORLD'

When you chop
Aim well! Don't slip!
And just make sure
She doesn't drip!

"A HATCHET FOR THE HONEYMOON"

N. W. Russo presents A University Associates Production
a GGP release PG IN COLOR

CALL IT A BASH! CALL IT A BALL! CALL IT A BLAST!

Beach party lovers make hey! hey! in the moonlight ...while the Monster lurks in the shadows!

THE BEACH GIRLS and the MONSTER

Music by FRANK SINATRA, Jr.

with JON HALL · SUE CASEY · WALKER EDMISTON · ARNOLD LESSING
and THE GIRLS from THE HOLLYWOOD WHISKEY-A-GO-GO
Produced by EDWARD JANIS · Released by U.S. FILMS, Inc.

A Comedy About An Experiment That Got **WAY OUT** Of Control!

SEAN YOUNG TIM DALY

DR. JEKYLL
AND
MS. HYDE

savoy pictures presents in association with rank film distributors a rastar/leider-shapiro production "dr. jekyll and ms. hyde" a david price film sean young tim daly
lysette anthony harvey fierstein stephen tobolowsky and jeremy piven co-producer frank k. isaac music by mark mckenzie editor tony lombardo
director of photography tom priestley executive producer john morrissey story by david price screenplay by tim john & oliver butcher and william davies & william osborne
produced by robert shapiro and jerry leider directed by david price

RASTAR

190

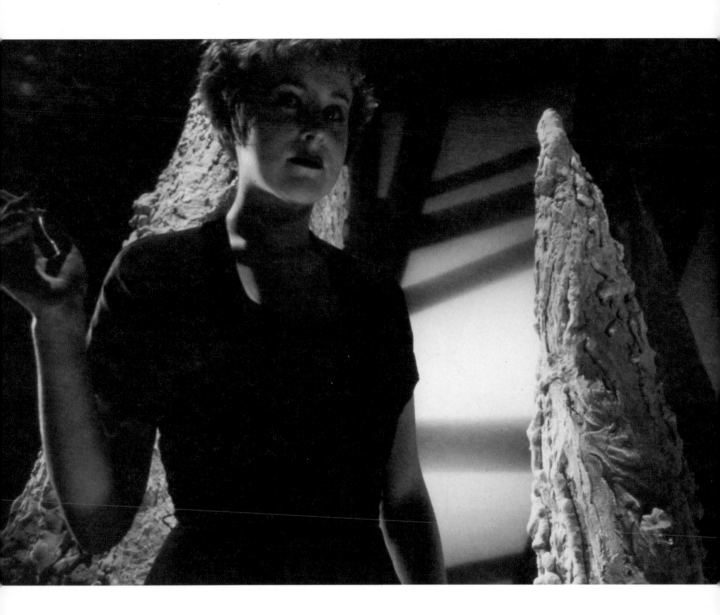

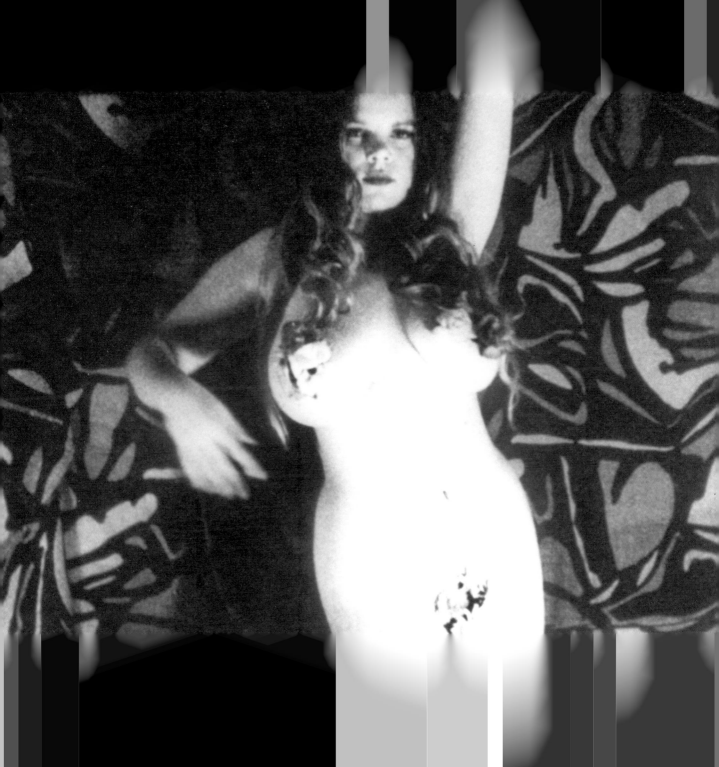

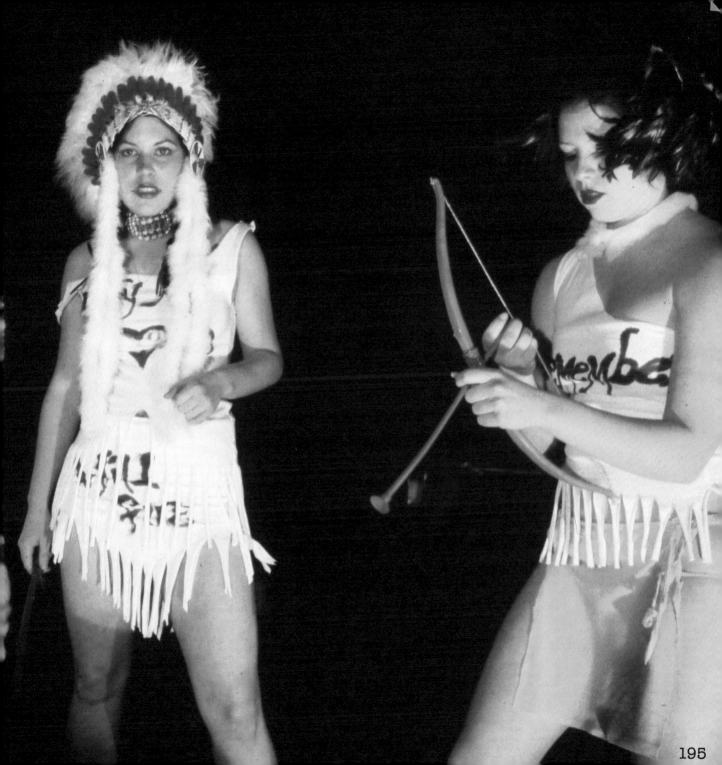

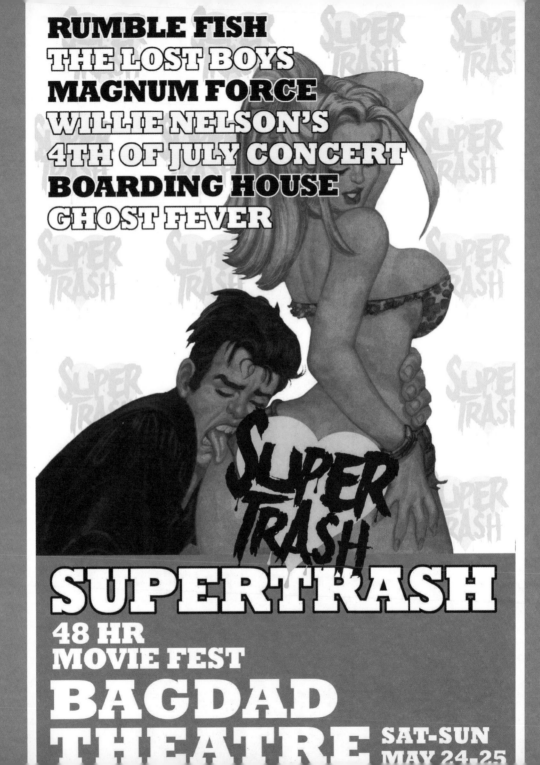

RUMBLE FISH
THE LOST BOYS
MAGNUM FORCE
WILLIE NELSON'S
4TH OF JULY CONCERT
BOARDING HOUSE
GHOST FEVER

SUPERTRASH
48 HR
MOVIE FEST
BAGDAD
THEATRE SAT-SUN
MAY 24-25

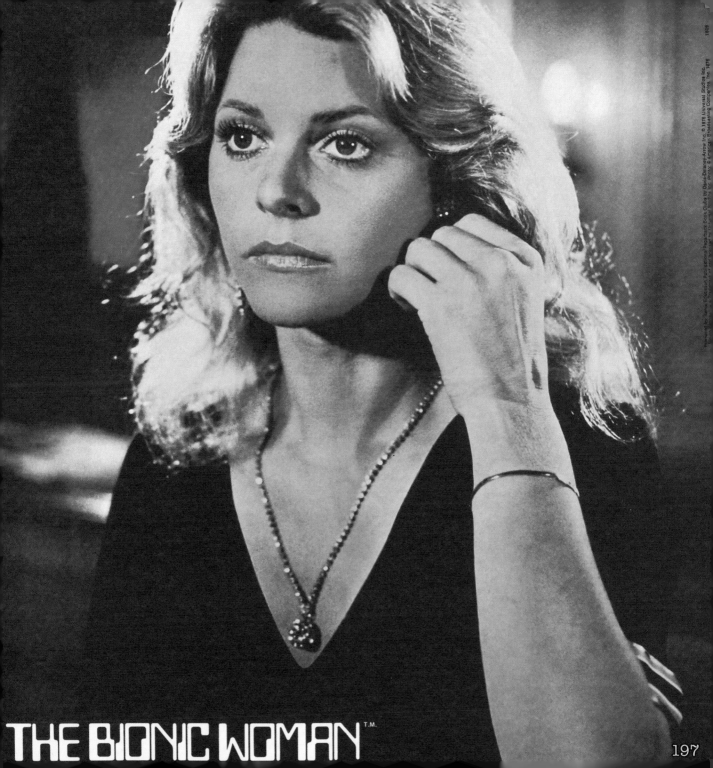

THE BIONIC WOMAN™

us

IND-34190

OCTOBER 14, 1980/75 CENTS

INVASION OF THE SUPER— BLONDES

Jigglier than ever, TV's golden girls now rule the tube

BURT REYNOLDS MIDLIFE CRISI **Sally Field told him "Shape up c ship out!**

Donna Dixon

Ann Jillian

Sophia Lore plays he mother in new movie and mama mi is mama ma

Jackson Brown

198

CINEFANTASTIQUE

May 1990 $4.95
Volume 20 Number 5 CAN $5.50
UK £3.50

STAR TREK VI
Koenig On Old Cast Axing

BACK TO THE FUTURE III
Wild West Action Preview

HOLLYWOOD'S FORGOTTEN MONSTER-MAKER

TOTAL RECALL

FIGHT DIRTY

Rolling Stone

BILLY IDOL
Sneer of the Year

VANESSA WILLIAMS
The Real
Miss America

TOM WOLFE
'The Vanities'

**HONEYDRIPPERS
JOHN FOGERTY
U2 IN CONCERT**

¡DRÁCULA REGRESA CON VORAZ APETITO POR LAS BELDADES DE NUESTRA EPOCA!

DRÁCULA
1972 D.C.

Una Producción Estelar Hammer

CHRISTOPHER LEE · PETER CUSHING

Y Estelares

STEPHANIE BEACHAM · CHRISTOPHER NEAME · Michael Coles

Guión de DON HOUGHTON

Productor Ejecutivo MICHAEL CARRERAS

Producida por JOSEPHINE DOUGLAS Dirigida por ALAN GIBS[O]

WB

para Warner Bros.

BH651 $1.95

—A Modern Barrio Novel—

PACHUCO

by Dennis Rodriguez

—The Hispanic Experience from Holloway House—

206

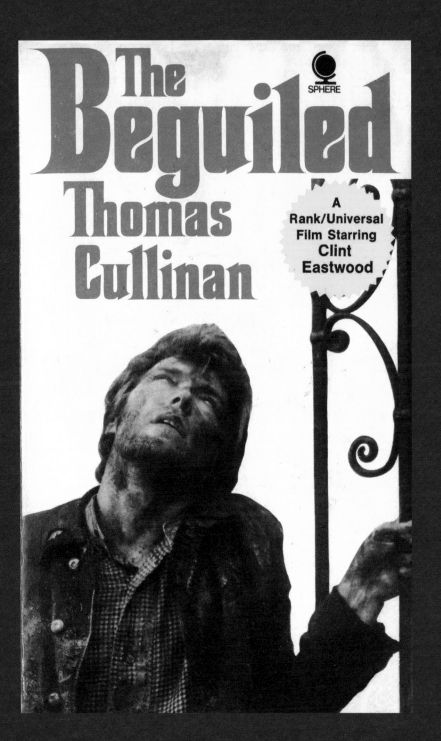

The
Beguiled
Thomas
Cullinan

A
Rank/Universal
Film Starring
Clint
Eastwood

SPHERE

ONE WEEK ONLY PLAYING AUG 24-30 THE CLINTON THEATER

SEX PDX

XPERIENCE SMUT & ROMANCE THROUGH THE AGES

SEE LOST HOME MOVIES BY RUSS MEYER

WET T-SHIRT CONTESTS FROM 1970S

VINTAGE BETTY PAGE AND NOTORIOUS XXX CANDY BARR

RON JEREMY & LISA DE LEEUW IN 1983 FEATURE "MOMENTS OF LOVE"

DIG THE "THE WILD WILD WORLD OF JAYNE MANSFIELD"

WAFT IN THE SCI-FI OF "CANDY VON DEWD"

EVALUATE "THE EROTIC ADVENTURES OF A MALE CHAUVINIST PIG"

BUILD CRED ON BLISTERING HOOKER-DOCS LIKE "STREETWALKERS"

NON-STOP NUGS OF VOYEURISTIC FUN

THAT'S SEX PDX!

CLINTON STREET THEATER & BREW PUB
IS AT 2522 SE CLINTON ST
503.238.8899 WWW.CLINTONSTTHEATER.COM
FOR MORE INFO CONTACT jboyreau@yahoo.com

Over 6 months on the
U.S. best seller lists

Deliverance

JAMES DICKEY

A NOVEL THAT WILL CURL YOUR TOES
...THE LIMIT OF DRAMATIC TENSION
New York Times

MEET THE EMPEROR
OF THE NORTH

This movie is about one hell of a man who lived when Dillinger was slamming banks, and Roosevelt was awakening the nation.

He's a hard-time fast-tracker who's been where it's mean. A grizzly with a sense of humor, an adventurer with holes in his pockets. A wandering rebel, living off the land by his wits and his fists. He goes it alone, he does what he wants—for the beautiful pure sweet hell of it. Who's going to stop him—you?

Now he's taking on his biggest run. A challenge no one ever survived. That's why he has to do it!

EMPEROR
OF THE NORTH
It's not a place...it's a prize!

20th Century-Fox Presents
LEE MARVIN · ERNEST BORGNINE · KEITH CARRADINE in "EMPEROR OF THE NORTH" · Co-starring CHARLES TYNER
MALCOLM ATTERBURY · HARRY CAESAR · SIMON OAKLAND · Produced by STAN HOUGH · Directed by ROBERT ALDRICH
A KENNETH HYMAN PRODUCTION · Written by CHRISTOPHER KNOPF · Music by FRANK DeVOL "A Man And A Train" Sung by MARTY ROBBINS
PG PARENTAL GUIDANCE SUGGESTED — Some material may not be suitable for pre-teenagers · Lyrics by HAL DAVID / Music by FRANK DeVOL · COLOR BY DE LUXE*

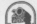

73/127

"EMPEROR OF THE NORTH"

SuperTrash End Notes

pg. 1. *The House of Hammer* (1977) is a pyrolatry, in league with the werewolf who is the fire of identity crisis.

pg. 6-7. The pairing of Vincent Price as "Egghead" and child combatants from *Taps* (1981) sensitizes the group helmet.

pg. 8. The album cover for *Thief* (1981) is a kind of werewolf-under-control, with two moons for eyes.

pg. 11. Orangutan Clyde from *Any Which Way You Can* (1980), as co-sphere of Gemini-signed Clint Eastwood, presents a twin for all to consider.

pg. 12-13. Color stills from *The Mummy's Shroud* (1967) and *Necromancy* (1972) "tactilize" traffic between dimensions: primal technology.

pg. 14-15. Patti Hansen and Dorothy Stratten in *They All Laughed* (1981) and Bernardo Bertolucci discussing *Last Tango in Paris* (1972) with Marlon Brando and Maria Schneider collectivize the "dire self" that exhibits new wave hookers and bad gods.

pg. 22-23. *Fangoria* magazines spoil the 1980s with Tennysonian gore per tooth and claw: red, pornographically stirred.

pg. 24, 69. Snaggletooth and Death Star Droid action figures link with a *Star Wars* of ambiguous gender--in the case of Greedo, the part was acted by both a male and female. Regarding prison, Genet said, "more doors are opened than closed." *Star Wars* "enforces" a similar assignment.

pg. 34. Olivia Newton-John on the back cover of *Making a Good Thing Better* (1977) is remarkable evidence of the Silk Road between the NWH and the BG.

pg. 37. A *TV Guide* cover (1981) featuring Prince Charles and Lady Diana Spencer is a heraldry of hermaphro.

pg. 38. John Carpenter on the set of *Dark Star* subtly projecting the stoner punkfidence of a "new" generation.

pg. 43. *Cathy*, from Topps Chewing Gum, is a monster consuming awe.

pg. 44, 114, 141, 142, 144. Topps' Wacky Packs such as *Czechlets*, *Chef Girl-ar-dee*, *Hawaiian Punks*, *Horrid*, and *Kentucky Fried Fingers* reveal the quantal messaging and invite-to-screwballism (if not radical politics) that product packaging can coach.

pg. 47. From the cover of *The Films of Boris Karloff* (1976), William Henry Pratt *alias* Karloff, ceremoniously glowers a very mask for the immutable.

pg. 48. Jerzy Kosinski, portrayed on the front of *Being There* (1970), is the writing within the Floydian Wall, the odyssey (particularly due to *The Painted Bird*) through which the 20th century may exhibistentially be known.

pg. 51-53. Topps' *Desert Storm* "Victory series" (1991) offers distinct proof that a global comic book is being perpetrated.

pg. 55. Peter Cushing as Grand Moff Tarkin would be pleased.

pg. 57. The aft cover of the album *Hitler's Inferno*, shows Hitler. Note the hermaphro pinkie. As Hitler once said, "The masses are feminine."

pg. 58. *Kim Carnes Voyeur* (1982): an example of 1980s German Expressionism (e.g., the cathedral factory [munitions?], the "hyperbolically white" dissatisfied Kyrie).

pg. 59, 68. The hermaphro solidarity of Shirley Temple is depicted in these violently yellow designs from the *Little Miss Shirley Temple* album.

pg. 60. Milton Bradley's *Stay Alive* (1971) teaches children to incant "I'm the sole survivor," colorfully accessorizing Bummer Power.

pg. 63, 64, 65. Bo Derek about to be legless in *Orca* (1977), Kris Kristofferson finding religion in *Pat Garrett and Billy the Kid* (1973), and Luke Cage bucking Black Mariah: these strangely ecstatic scenes are a coffle of breast-feeding imagery, motherly retribution, rowdy blubber.

pg. 66-67. The pairing of *Garbage Pail Kids* "Michael Victim" with Ann Reinking from *Movie, Movie* (1978) is a crack example of polymorphous pattern-recognizane: fashionable entrails = platinum perm.

pg. 72. In a notably chastised performance as a mother-fixated sadistic queer, Richard Burton in *Villain* (1971) drops serious bad god napalm--his Scorpio toxicity fucks the dog and shits on the cake.

pg. 74-75. The diptych of *Negro Prison Songs* and the Asian cheese-puff infant from *Eat!* evokes atavisms of racial etiquette, which like indestructible matter, funnel to Big Other.

pg. 77. Marvel's Shang-Chi seems the logical chef for rice drills in the *Superheroes' Cookbook* (1977), yet brings up the dilemmatic inquiry: was the 1970s Marvel Universe ethnically ahead or stilted? The issue is whether "tokenism" can also be "totemic." Excelsior!

pg. 83. From the paperback *Soldier Blue* (1970), the intensely sexualized Cheyenne maiden implicates the "human rights" sallies of the 1970s (i.e. behind every bondage, another).

pg. 84. Matt Dillon in *My Bodyguard* (1980), a li'l bad god cutie! Hermaphro as hell, with a li'l new wave hooker glued.

pg. 87. The album cover *Eric Carmen Tonight You're Mine* (1980) is slavishly SuperTrash. It has a cyber grid, the *2001* monolith via the *Phantasm* portal, a lipstick horizon, the epicentral new wave hooker, and the pathetic ego of a bad god on permanent display.

pg. 89. Before he "earned respect" for being quirkily solemn, Tommy Lee Jones lent to a symbolism much darker, more *giallo*, less patriotic--in *Eyes of Laura Mars* (1978), he

derives the original bad lieutenant from a schizoid blend of hypersensitive nihilism and explosive timidity.

pg. 92, 218. Stella Stevens and Jerry Lewis in *The Nutty Professor* (1963) are here to remind that Jerry is the Chuck Norris of SuperTrash: unvanquishable.

pg. 94-95. The pairing of Eddie Rabbitt and Claudine Longet trembles at the atomic level of hermaphro.

pg. 108. The portrait of a Mandan chief by Karl Bodmer, from Time-Life Books *The Indians* (1973), promotes the consanguine duality of nobility/savagery that perilously enables what we call survival.

pg. 112. From the paperback *Coffee Tea or Me?* (first published in 1967), the obsidian-winged stewardess has the authority of a Nazi eagle--her dominion banishes her to serve.

pg. 124. Marvel's *Brother Voodoo* (1973) reveals volumes of what the 1970s were up to: the value proposition--seen throughout blaxploitation movies and taken from 1960s Black Power/Black is Beautiful--that to be black was sufficient grounds for superhero behavior.

pg. 128, 174. *Famous Monsters of Filmland* sold covers that stood like art pieces--classy, trashy, consummately disposed to eye contact, bringing you and monster closer. Interestingly, did *Plague of the Zombies* (1966) inspire the Zodiac Killer's mask?

pg. 129. What was the most potent drug in John Belushi's ravenous life? Heroin? Cocaine? Big Macs? The punk rock of Fear? Chicago winters? Despite fulgurant extrovertism, Belushi thrives as major enigma.

pg. 131. *Vampirella* (1979) is more than woman or monster, she is fashion statement. A religion perhaps, apropos to the notion the vagina is a cave for bats.

pg. 132. *Red Sonja's* fashion suggests a collaboration between bikini and chastity belt--even with her prejudice for combat over sex, she herds sexy beasts. (How often does a Marvel creature flash ass?)

pg. 134. The Cannon Video comic of *Cyborg* (1989) contributes its bit to the "gay porn" momentum of Jean-Claude Van Damme's career, culminating around *Death Warrant* (1990).

pg. 136-137. The pairing of Colonel Kurtz and Darkness makes a lot of sense; both are bald.

pg. 139. Prior to 9/11, the layout of the original *Trash* contained this lobby card from *Meteor* (1979), uncannily pre-visualizing the event. The publisher, Chronicle Books, assuming no one would accept the image had been placed before it came true, decided on removal. Such "prophecies," including the poster for *Die Hard* (1988), cause my belief that event planners diagnose movies for ideas.

pg. 140. Sylvester the centerfielder "washes his hair in ketchup." I feel his wounded bewilderment.

pg. 147. From the paperback *Ratoon* (1968): lacerating chiaroscurist body lingo, shadows brighter than light, America's inevitable Africa visible, the charge of the large brigade.

pg. 149. *Robot Jox* (1989) extends the clout of bigger-is-better into the realm of bigger-is-ridiculous.

pg. 150. Topps brands *Fright Flicks* with an illustration based on *Fright Night* (1985), thereby acknowledging the orally endowed, *Jaws*-y vamp was an innovative depiction (in touch with 1980s greed).

pg. 152-153. The pairing of Michael Landon and Bigfoot is another crack example of polymorphous pattern recognizane: Landon's 'do = Bigfoot's bod (we surmise further Landon felt he was the werewolf still).

pg. 166-167. The pairing of *Cruising* (1980) and *Creepy* (1967) approach rough trade as a kind of regal "sexecution"--a laconic mythology of final penetration.

pg. 169. I have always considered Maximilian from *The Black Hole* (1979) a "black" robot, as if Darth Vader were Willie Dynamite. Groping the world like a comic book, SuperTrash knows robots are politics; the contours of Maximilian seem enraged by a cause.

pg. 175. The news photo of Linda Blair and pit bull (by Rich Pedroncelli for AP) is cute and "obscene"; the technology of the dog's mouth is infernal, like a lubricatorium for Videodrome labia; this image smiles for an exorcist.

pg. 191. *The MAD Adventures of Captain Klutz* (1967) by Don Martin upends the already-absurd as Klutz engages Sissyman, The Zombies of Megapolis, The Mad Bomber, and Gorgonzola; in the process he often manages to somehow turn into a terrorist.

pg. 198-199. The pairing of Charlene Tilton with the She-Creature rocks hermaphro: "spunky" blond is the triumph of femijism and female monster hides a man.

pg. 201. Hunkering almost to a squat on the album cover *Fight Dirty*, this new wave hooker means business.

pg. 202. While it is tempting to designate Billy Idol a bad god, his forte is NWH. What does the world need more of? Punk glam.

pg. 206-207, 209, 216. Re: punk glam, the paperbacks: *Pachuco* (1980), *The Beguiled* (1971), *Deliverance* (1970), and *Apache #10 All Blood is Red* (1977)--convey possibilities that punk glam will have nothing to do with guitars.

pg. 219. This "excerpt" from *Playboy* "Miss September" is a piece of flag. Sweet Land of SuperTrash.

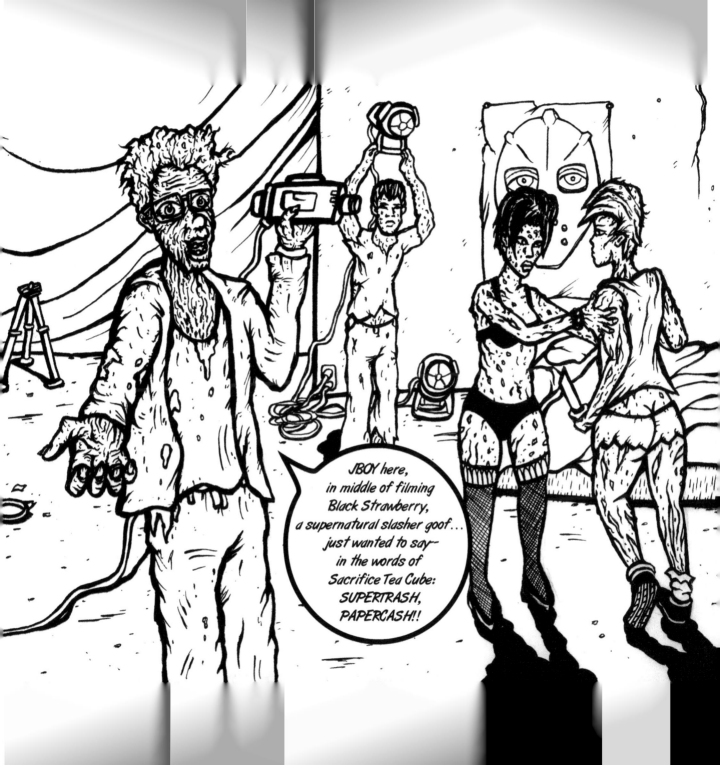

Cuchillo Oro, the Apache warrior,
is the prey—hunted by a lynch mob
bent on vengeance.

by William M. James

Apache
#10
ALL BLOOD IS RED

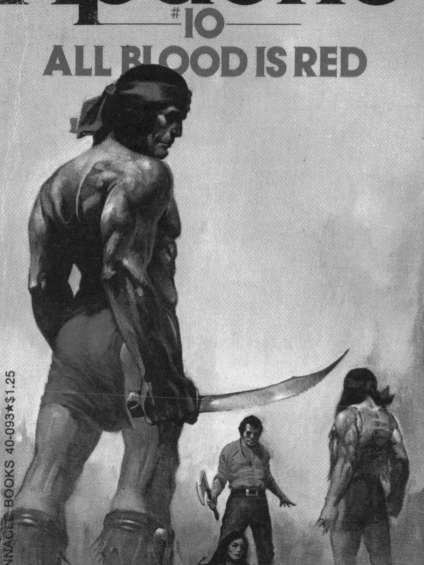

PINNACLE BOOKS 40-093★$1.25

In the heart of every victim is a hero and he'll
tear apart a city to prove it.

PURSUED

ARNOLD KOPELSON Presents A JOE NIEM Production

JACQUES BOYREAU CLIFF GORMAN RICHARD CASTELLANO

Director of Photography
VICTOR J. KEMPER A.S.C.

Music
ARTIE KANE

Based on the Novel by
WILLIAM P. McGIVERN

Screenplay by
BILL NORTON SR. & RICK NATKIN

Executive Producer
ARNOLD KOPELSON

Produced by
JAY WESTON

Directed by
ROBERT BUTLER

"NIGHT OF THE JUGGLER"

220

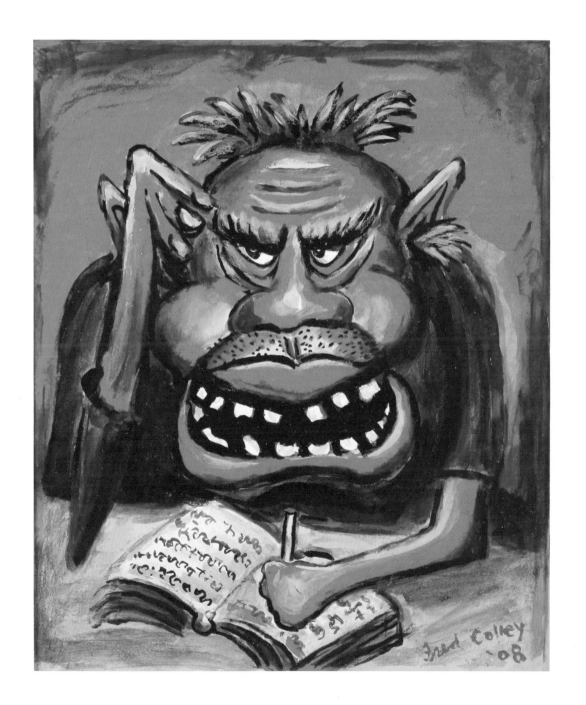